JULY 2018

SARA RISHFORTH

BEND FOOD

STORIES OF LOCAL FARMS AND KITCHENS

FEATURING PHOTOGRAPHY BY EMIL TEAGUE

AMEF

Winnetka-Northfield Public Library District
Winnetka, IL 60093
(847) 446-7220

Published by American Palate
A Division of The History Press
Charleston, SC
www.historypress.com

Copyright © 2018 by Sara Rishforth
All rights reserved

First published 2018

Manufactured in the United States

ISBN 9781467139007

Library of Congress Control Number: 2018932119

For Emil. Thanks for riding along with me on this latest adventure!
We make a good team.

CONTENTS

Contents

ACKNOWLEDGEMENTS

This book is dedicated to the farmers, chefs, advocates and people involved in the farm-to-table movement. Thanks for your kind hospitality and openness to the project! You made time for me during the busy summer and fall season, and I appreciate it so much. Thank you for sharing your knowledge and personal stories.

A heartfelt thank-you to Arcadia Publishing and The History Press. The guidance and kind feedback from my editor Laurie Krill was invaluable. She answered many questions throughout the duration of the project. Also, thank you to Hilary Parrish for her edits and attention to detail. I'm in awe of your knowledge of *The Chicago Manual of Style*! Thank you as well to Sarah Haynes in the marketing department and Crystal Murray, my sales specialist.

Stella Fong, who wrote *Billings Food*, deserves special recognition. Your encouragement was instrumental in my leap to write this book. On your next visit to Bend, we'll eat some delicious local food together.

I'm grateful to Tracy Miller, Michele Wyman, Terese Jarvis, Sue Fountain, Vanessa Ivey, Megan French, Karen and John O'Donnell, Karen and Richard Brodsky, Debi Shimek, Karen Pollard, Kathleen Coop, Laurie Wayne and all of my Mount Bachelor and Touchmark co-workers for your kind support.

During the lengthy editing process, I took many baking breaks and went through a shocking quantity of butter. Thanks to Candace Weber for taking all those cookies, quick breads and muffins off my hands. She's the most appreciative person I know and always sends a sweet thank-you note.

I owe so much to my parents, Daryl and JoAnn Rishforth. They taught me a strong work ethic, kindness, generosity and love. My time in the kitchen and love for food is all due to them.

My deepest gratitude to Emil Teague. I never asked if you would take photos or edit the manuscript—just assumed you would be on board with it. Thanks for your wonderful photographs, patience and brutal criticism during a tough and stressful time. You listened to me talk about the book and nothing else for six straight months during the research and writing process. There were many late nights as we pored over thousands of photos, and you spent your days off from work with me as we traveled all over Central Oregon to farms and restaurants. Your gentle encouragement and sense of humor kept me laughing during my pit-of-despair moments. Bears growing green beans, carrots showing vegetables for sale and goats scampering will always make me laugh.

An apology to you if your favorite restaurant, farm, producer or organization isn't included in this book. For a variety of reasons, I couldn't list everyone in the community. Central Oregon has so many talented folks involved in the farm-to-table movement. They influence the food we eat, harvest bountiful amounts of local produce and nourish our community. They bring us together in countless ways. Thanks for everything you do!

INTRODUCTION

There is no love sincerer than the love of food.
—George Bernard Shaw

My goals for this book are simple: introduce you to hardworking and passionate farmers in Central Oregon so you can learn about the many options to buy local food; allow you to meet chefs embracing the farm-to-table movement by purchasing from local farms; get you to take action by becoming involved in the local food community.

Eating is a social act and more than just sustenance. We invite friends over to our homes, enjoy a meal and engage in meaningful conversation together. We try new restaurants, share recipes with friends and spend time in the kitchen. Food brings people together and connects them in many ways, both emotionally and physically. The word *locavore* was coined in San Francisco in 2005, and it means a person who seeks out and savors locally grown and raised foods. You're a locavore by picking up this book.

I hope you enjoy reading this book and looking at the photos. After every interview with a farmer, chef, business owner or advocate, I reflected about my time with them and the information and stories they shared. They inspire me to walk down to the Bend Farmers' Market on Wednesday for zucchini, sign up for community food events and savor the locally grown vegetables in the Sunny Bowl at Sunny Yoga Kitchen.

MY ADVENTURES IN FOOD

I was adopted at six months old from Seoul, South Korea, and raised primarily in Greenville, South Carolina. My family is Caucasian, and I have two brothers (not adopted). Written by my mother, most of my baby book entries are about food. Here's an entry: "At 7½ months, Sara is a good eater. Loves everything, especially crackers. At age 15 months, loves cookies, macaroni, and bananas." I'm still a good eater, so nothing has changed.

My mother is a wonderful cook, and we always had dinner together as a family. My brothers are significantly older, so they were out of the house already when I was in middle school. I loved going to the grocery store with Mother and fetching items from her long list, always written on the front of a recycled envelope. Some favorite home-cooked meals from my childhood are creamed chip beef on wheat toast, fried pork chops dredged in flour with lots of pepper and kielbasa with sauerkraut. My parents were transplants from Cincinnati, Ohio, so I didn't grow up eating too much southern food at home. We ate out occasionally and enjoyed southern cooking, especially breakfast at Tommy's Country Ham House. I love southern food and make it frequently; a good casserole makes everything better!

The summer when I was thirteen years old, Mother paid me to cook weeknight dinners, thinking it would keep me occupied and out of trouble. I loved looking through her cookbooks, and my favorite one was the *Southern Living Annual Cookbook*. After several weeks of heavy elaborate meals, she suggested I make something simple like soup and sandwiches. My parents came home from work the following evening to homemade tomato soup and triple-decker club sandwiches. Mother had meant heat up a can of minestrone soup and make grilled cheese sandwiches.

My memories revolve around food, whether dining out or home cooking, and certain memories stand out, particularly if the food is good. There are times when it is so delicious, I don't talk while eating because I'm savoring each bite.

Here's a list of my favorite meals:

- The McIsley Biscuit Sandwich at Pine State Biscuits in Portland, Oregon—coarse-grain mustard, honey, pickles, juicy fried chicken on a homemade biscuit. Yep, it's quite filling. I've eaten at every location, and I like the SE Division spot best.
- Chicken on a Bun at Craft Kitchen & Brewery in Bend, Oregon. The chicken is so juicy and flavorful. I don't share

any bites of this sandwich, and there's no talking while I slowly eat it. I mentioned this sandwich to my hairdresser, Amy. She immediately gushed about the tasty sauce served on it. Bonding over food while chopping off eight inches of hair!

- Roast Grouper at Hank's Seafood Restaurant in Charleston, South Carolina. Fresh seafood in this lovely town. Thanks to my parents for recommending this restaurant!
- Pork Belly Braised in Root Beer at Screen Door in Portland, Oregon. I am so in love with this dish! I even wrote *Bon Appetit* magazine to ask Screen Door for its recipe for the "R.S.V.P." section. No reply. Yet.
- Mochaccino Cake by Chef Sara Spudowski. Or her roasted potatoes; it's really a toss-up. Everything she makes is fantastic. Chocolate chip cheesecake, red velvet cupcakes, profiteroles and more. I dearly miss our Allen & Petersen days!

Continuing along the food journey, my first job was at a mall restaurant when I was fourteen years old. This kicked off many positions in the hospitality industry, from front-of-the-house to back-of-the-house, including making tacos at a Mexican restaurant. These days, I work part

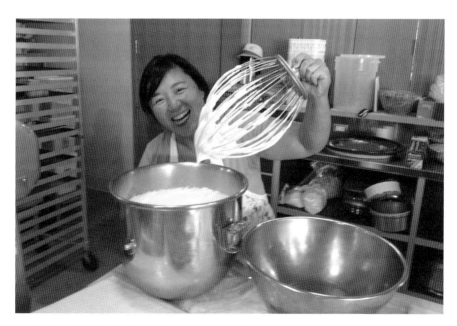

Author Sara Rishforth mixes whipped cream at the Americana Song Academy. *Photo by Natasha McEuin.*

time as a kitchen assistant to Annie Johnston, owner of Annie's Kitchen. She's a traveling chef, and we cook at events all over the Pacific Northwest. We haul food to established kitchens and feed groups ranging from 20 people to 200. I've worked for her since 2012, and it has been quite a learning experience—mixing up cornbread for 120 people, making her famous black bottom cake, honing my active listening skills and, most importantly, food presentation. She excels at creating beautiful platters of fruit, salads and appetizers, plus has a huge selection of gorgeous serving dishes. We work very differently in the kitchen yet succeed as a team. I'm the non-talker who prefers a written prep list.

I've always looked forward to shopping at farmers' markets and enjoying the beautiful produce grown by local farmers. This book gave me the wonderful opportunity to engage with farmers, learn ways to support the community and be inspired by local chefs. The Central Oregon community is active in the farm-to-table movement, which will continue increasing as diners inquire more about their food. Farmers will grow new crops each year, people will seek out local food and chefs will show their passion through creative menu offerings. Thanks for joining me on this adventure!

OREGON HISTORY

O regon is big. Not Alaska or Texas big, but it's the ninth-largest state in the Union, joining in 1859. At 295 miles south to north and 395 miles east to west, it takes a long time to drive across, especially with several mountain ranges and rivers to cross and extensive lava fields to detour around. The landscape is shaped by millions of years of eruptions, lava flows and volcanic ash. Oregon has many extinct volcanoes, and the landscape is dotted with buttes, cinder cones and craters. Newberry volcano, located twenty miles from Bend, is the largest volcano in the Cascade Range and is potentially still active. With jagged cliffs and breathtaking views, the Oregon coast looks west over the Pacific Ocean swells. Mountain ranges run north and south, creating climate zones as the wet Pacific Ocean weather moves inland, dropping moisture as it moves east. Precipitation across the state varies.

Area	Average Rainfall
Tillamook (coastal town)	88 inches
Eugene (Willamette Valley)	46 inches in foothills, 80 inches in higher elevations
Portland	36 inches
Bend (Central Oregon)	11 inches
Alvord Desert (Eastern Oregon)	7 inches

Central Oregon is a high plateau, with the Cascade Range to the west and the Ochoco Mountains to the east. This area is often referred to as the High Desert and receives very little rainfall. Even with bright, sunny days, there is little to keep the heat trapped overnight, and there can be a fifty-degree drop in temperatures. The Deschutes River runs north through the region, flowing over 250 miles from its headwaters to where it joins the Columbia River.

At about the middle of the river and not far from the geographic center of Oregon is Bend, incorporated in 1904 with a population of three hundred residents. Bend's first commercial sawmill was built in 1901, and the logging town flourished, with two more lumber mills completed in 1916. Deschutes Market Road and Reed Market Road are aptly named since these roads were used for moving agricultural products to the market. The State of Oregon statute in 1919 defined these roads as vital to economic function. They received special consideration for funding. There are over fifty market roads in Deschutes County, named after the landowners living in the immediate area.

Bend's elevation is 3,623 feet above sea level, and the climate is arid, with relatively low humidity. Each part of town has its own microclimate. For neighborhoods located in higher elevations, there is more snow accumulation and cooler temperatures than the east side of town. With approximately three hundred days of sunshine, Central Oregon attracts many outdoor enthusiasts. In the spring, locals can ski or snowboard in the morning at Mount Bachelor and join friends for a round of golf in the afternoon. Bend's average snowfall is 23 inches, while Mount Bachelor, twenty-two miles away, has an average snowfall of 462 inches. It's amazing how much weather changes at different elevations.

On July 24, 1991, Deschutes County received four and a half inches of rain in an hour. A mudslide took out part of a highway, and six to eight inches of hail covered Century Drive, on the west side of town. Imagine being a farmer during this weather event!

NATIVE AMERICANS AND EARLY SETTLERS

Native Americans lived all over Oregon, and the first evidence of their habitation is 11,500 years ago at Fort Rock in Lake County. In Deschutes County, Molala Indians occupied the west and Northern Paiute the east.

SEASONAL ROUND

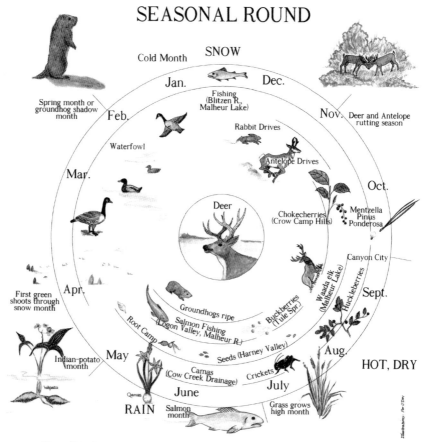

Cold Month **SNOW**

Jan. Dec.

Fishing
(Blitzen R.,
Malheur Lake)

Spring month or
groundhog shadow
month Feb. Nov. Deer and Antelope
rutting season

Rabbit Drives

Waterfowl

Antelope Drives

Mar.

Oct.

Deer

Chokecherries Mentzella
(Crow Camp Hills) Pinus
Ponderosa

Canyon City

Waada elk
(Malheur Lake) Sept.

First green
shoots through Apr.
snow month

Groundhogs ripe

Root Camp

Salmon Fishing
(Logon Valley, Malheur R.)

Buckberries
(Tule Spr.)

Huckleberries

Indian-potato
month May

Seeds (Harney Valley)

Aug.

HOT, DRY

Camas
(Cow Creek Drainage)

Crickets

Qamas

June July

RAIN Salmon
month

Grass grows
high month

Harney Valley Paiute seasonal round. Based on Conture (1978) Housley, and Ricks (1982) Whiting (1950)

Seasonal round of food hunted and gathered by Northern Paiute groups. *Courtesy of Deschutes County Historical Society.*

Groups followed the seasonal ripening of berry bushes, nuts and seeds. Plants were used for food, medicine and cultural purposes, including baskets, shelter, tools and in ceremonies. Hunting and fishing were popular, with some of the game dried and stored for the winter months. Dried salmon was often traded among the different Native American tribes. A unique feature of the landscape is obsidian, a volcanic glass formed by lava flow. It was used as arrow tips in hunting or other cutting tools.

In the first decades of the nineteenth century, fur trappers from Hudson's Bay Company arrived. They settled in Vancouver, Washington, and set up their western operations. Trappers explored all over Central Oregon,

building relationships with the Native Americans and often using them as guides. In December 1825, Peter Skene Ogden led an exploratory trip up the Deschutes River and then continued northeast along the Snake River into Washington and Idaho.

In 1846, John Y. Todd probably drove the first herd of cattle over the Cascade Range to Central Oregon. Many of the early settlers in the upper Deschutes County were cattle and sheep ranchers taking advantage of the available wide-open spaces for grazing. Santiam Wagon Road was built between 1861 and 1868. It connects the Willamette Valley to Central Oregon and operated as a toll road from 1866 to 1914, providing a road for settlers and an avenue to transport goods back and forth.

The Donation Land Claim Act of 1850 brought settlers to Oregon via the Oregon Trail with the promise of free or inexpensive land for agricultural purposes. It was enacted by Congress to legitimize the de facto claims of settlers already in the Oregon Territory and to authorize new claims. Oregon's population grew quickly despite many heading to California instead to search for gold.

Before December 1, 1850, a married couple could claim 640 acres (one square mile), and a single white male could claim 320 acres. The claim was split in half between the husband and wife. Between December 2, 1850, and December 1, 1854, a married couple could claim 160 acres and a single white male could claim eighty acres. A total of 7,437 titles of land were issued by the end of 1855. After the claim period, available land for purchase went for $1.25 an acre up to 320 acres. Over time, the price increased and the acreage quantity decreased.

Deer, elk and bear were plentiful when the first settlers arrived in Bend. Hunting was the main source of food, along with planting a garden in the summer. Some settlers brought seeds such as wheat, corn or other vegetables. Seeds, coffee, tea and other items were for sale from Hudson's Bay Company. Most farms also had cattle, sheep, poultry or hogs.

IRRIGATION

The Carey Act of 1894, also known as the Federal Desert Land Act, helped develop arid lands through irrigation. The federal government donated 1 million acres to the western states in the hopes of the land being reclaimed, settled and cultivated. The private companies in charge of the

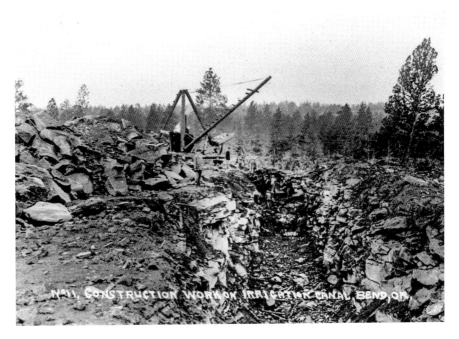

Construction of an irrigation canal near Bend, Oregon. *Courtesy of Deschutes County Historical Society.*

irrigation were originally reimbursed ten dollars an acre for settled land. However, this proved to be less than the cost of building canals. From 1904 to 1912, several irrigation companies constructed canals to irrigate thousands of acres in Central Oregon, and this became a desirable place to live. By 1902, there were 440,000 acres irrigated, the majority located in eastern Oregon. When Bend was incorporated in 1904, irrigation and development were at the forefront, with Central Oregon Canal and Pilot Butte Canal completed in 1907.

Water from the Deschutes River flows through a maze of canals that branch out to reach individual farms. Gates at each farm are opened for a certain amount of time based on the amount of land that can be irrigated. Water rights are obtained by applying for a permit and building a system to use it. An examiner then completes a survey for the Water Resources Department.

MEET YOUR FARMER

We abuse land because we regard it as a commodity belonging to us.
When we see land as a community to which we belong, we may begin to use it
with love and respect.
—Aldo Leopold

LOCAL FOOD

When I refer to "local" food, I consider one hundred miles or less from Bend to be local. It's not a universal number, but it's the number most frequently used. Fields Farm is a half mile from my home, and Rastovich Family Farm is less than four miles away. Access to local food is easier than ever these days. During the summer, local farmers' markets operate every Tuesday, Wednesday, Friday and Saturday. Central Oregon Locavore's marketplace is open six days a week. Conventional grocery stores now carry many locally grown items. Many restaurants proudly use local produce and meats in their daily offerings.

In general, local food is more nutrient-dense and tastes better since it's picked at the height of ripeness. There's less packaging or processing involved. It uses less fossil fuels in transportation because the food isn't traveling far to reach your plate. On average, food travels 1,500 miles from farm to plate. Conventional agriculture chooses varieties to withstand shipping, durability and a long shelf life, while taste may not even be a

consideration. Have you seen green bananas or squeezed a rock-hard nectarine at the grocery store?

You are supporting the local community and farmer by buying their produce, meat, eggs and locally made products. Local farms provide diversity in produce available. Novicky's Farm and Mahonia Gardens grow heirloom varieties of tomatoes, full of flavor but not perfectly red and round like varieties sold at conventional grocery stores. Knowing where your food comes from and how it is grown provides intangible enjoyment and helps make better food decisions.

Fun fact: Oregon leads the nation in the production of Christmas trees, grass seed, hazelnuts, onions and blackberries. Other major crops are hops, raspberries, cauliflower, plums and pears.

TYPES OF FARMS

There are many types of farms, with several highlighted in this book. A small farm, as defined by the U.S. Department of Agriculture (USDA), grows and sells between $1,000 and $250,000 per year in agricultural products. According to the 2007 census, small farms compose 91 percent of all farms, with the majority located in New England and the South. Small farms increased 1 percent from 2007 to 2014. Mahonia Gardens is an excellent example of a market garden, having fewer than three acres in production. A market farm, like Fields Farm, is between three and twelve acres.

MARKETING

Marketing is an important part of farming success, and a smartphone has become one of the most important tools these days. Photos of freshly harvested produce pop up on Facebook, Instagram and Twitter feeds, along with reminders of Community-Supported Agriculture (CSA) pickups. Fields Farm is active on social media and posts photos of available crops, like a four-and-a-half-pound Chioggia beet plucked from the ground that morning. Great American Egg uses e-mail to announce upcoming Larder Days, when customers can stock up on fresh chicken. Farming is a lifestyle, and many farmers want to share it with consumers.

Display of fresh produce at the farmers' market. *Photo by Emil Teague.*

Mahonia Gardens, Fields Farm and Dome Grown Produce sell their produce at farmers' markets, through CSA memberships and to wholesale markets. Barley Beef, Novicky's Farm, Tumalo Fish and Vegetable Farm, Golden Eagle Organics, Inc. and Great American Egg sell their products directly to consumers, restaurants or other outlets. Each farm, depending on its production, is different and engages in a variety of ways.

FARMING STATISTICS

Following are some Oregon Department of Agriculture facts and figures from 2016:

- There are 34,400 total farms in Oregon.
- 61.4 percent of farms are fewer than forty-nine acres.
- The average age of a farmer in Deschutes County is fifty-nine years old; it's nearly the same in Crook and Jefferson Counties.
- In Deschutes County, from 2012 to 2007, there was a 9 percent decrease in the number of farms.

In 2015, the Local Food Marketing Practices Survey was the first survey to produce data about local food. It hopes to conduct another one following the 2017 Census of Agriculture. Here are a few key statistics from the survey:

- In 2015, Oregon and Washington produced and sold $264 million edible food commodities directly to consumers, retailers, wholesalers, institutions and distributors.
- Oregon had $114 million in direct farm sales and ranked eighteenth out of the published states, accounting for 1 percent of all direct farm sales.
- Fresh food sales constituted 62 percent, or $71 million, of total Oregon direct farm sales.
- Direct to consumer via farmers' markets, CSAs and roadside stands accounted for $53.2 million in Oregon.
- 46 percent of Oregon farmers involved in direct to sales are female, compared to 38 percent nationally.

Finding affordable land is a big challenge for many new farmers, whether leasing or taking out a loan to buy land that may need improvements or structures built. The USDA New Farmers website lists resources and checklists, offers business advice and aids in planning. High Desert Food & Farm Alliance (HDFFA) and Agricultural Connections (AC) are also good resources for farmers in Central Oregon.

ORGANIC VERSUS NON-ORGANIC

There are many farms in Central Oregon that are not certified organic but still follow the strict USDA guidelines. Open up the dialogue when you meet farmers and ask about their operation. They'll gladly talk about their processes and growing practices. Many farms have websites and are transparent about how they grow healthy, delicious and safe food yet choose not to be certified organic for a variety of reasons. Please don't pass by their booth or not consider a CSA from them just because of the lack of organic labeling. They grow sustainably produced food and are stewards of the land.

Organic certification is an arduous and costly process to meet the USDA guidelines. The cost depends on size, type and complexity of the operation, plus an annual review and inspection. Once certified, farms are eligible

for reimbursement up to 75 percent of the fees in the application process. In order to be certified organic, virtually no chemical pesticides, fertilizers or synthetic ingredients may be used in the farming process. Seeds or transplants are chemical-free, and all fertilizer is organic. Farm inputs such as fertilizer or potting soils must contain the seal of approval from the Organic Materials Review Institute (OMRI). Animals are fed only organic feed, and no antibiotics or growth hormones are administered. Products labeled 100 percent organic cannot contain genetically modified organisms (GMOs). For farms transitioning from conventional to organic, documentation is necessary to show the last time chemicals were applied, and there must be a minimum of three years from last application to the first certified organic harvest. Becoming organic is about more than just the items you cannot use while farming. It's about building soil, crop rotation and other practices leading to a healthy overall system.

Taste, lack of pesticides and environmental impact are a few reasons why people choose organic food. Farms selling less than $5,000 a year can call themselves organic without paying for certification as long as they follow the above rules. There are over twenty-two thousand certified organic farms and businesses in the United States, and sales of retail organic products were $43 billion in 2015.

BARLEY BEEF

Juniper trees edge the pasture, with the snowy summit of Mount Bachelor clearly visible against the bright blue sky. Beyond the barn and outbuildings, cows have ample room to graze. "I was born into it," says Rob Rastovich as he gestures toward the expansive farm. His grandparents George and Anna homesteaded two hundred acres in 1919, establishing the Rastovich Family Farm. They raised seven children in the farmhouse and a separate bunkhouse. Rastovich tells me the older boys slept there, with the youngest children in the farmhouse. He takes me on a tour of the farmhouse, clean and comfortable, with furniture and pictures collected by generations of his family. In 2019, the farm will celebrate one hundred years; it will be the first farm in Deschutes County to reach this significant milestone.

Barley Beef started in 1993 as a collaboration of small family-run ranches, including Rastovich Family Farm, Borlen Cattle Company and a few others. Borlen was picking up a couple hundred pounds of beer mash from Deschutes Brewery to feed five cows. Now, six local breweries supply 230,000 pounds of beer mash a week for cattle feed. Strained from the distilling process, beer mash consists of spent wheat, hops and barley. Farmhands also pick up waste water from the brewing process that would otherwise be dumped down the drains and into the sewer treatment system. The beer water contains wheat, hops and barley and is high in nitrogen.

There are approximately two hundred cows on Rastovich Family Farm, plus one hundred additional cows on leased land. All of the cows are sourced from Oregon and never given hormones or artificial growth substances.

Right: George and Anna
Rastovich homesteaded
two hundred acres for
Rastovich Family Farm
in 1919. *Courtesy of Rob
Rastovich.*

Below: Barley Beef picks
up approximately 230,000
pounds of spent grain
weekly from breweries.
Photo by Emil Teague.

The farm manages its herd size based on the amount of available beer mash. More beer consumed leads to more cattle fed and butchered. Cows for ground beef are seven to eight years old. Steers that are at least 1,400 pounds, at about two years old, are sold in halves and quarters to make primal cuts. Current butchering is approximately 2,000 pounds of ground beef a week and four steers a month. Grass-fed cows tend to have a more pronounced distinctive, beefy, gamey flavor. Corn-fed beef tends to be more marbled with fat and has a milder taste. By feeding its cattle grass and hay and adding beer mash for the final three to six months, Barley Beef produces tender, well-marbled beef with great flavor.

About 60 to 70 percent of Barley Beef's business is commercial, including Deschutes Brewery & Public House and other local restaurants. The rest is sold to individual customers, with orders delivered by a refrigerated truck. Barley Beef sells packs of meat in a variety of sizes. The sampler pack contains ground beef, steaks and roasts, about twenty-five pounds total. I ask Rastovich about favorite cuts of meat and preparation. "Rib steaks are

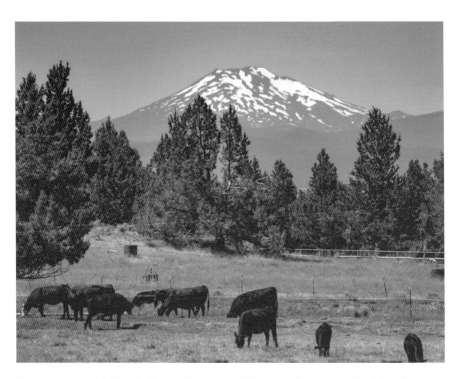

Pasture at Rastovich Family Farm with a view of Mount Bachelor, elevation 9,065 feet. *Photo by Emil Teague.*

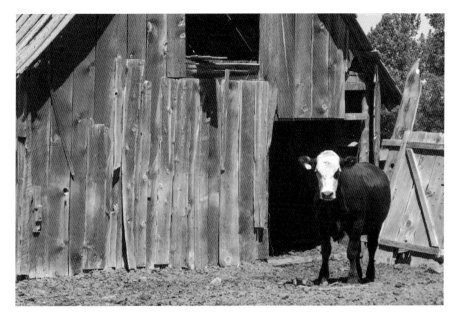

A lone cow at Rastovich Family Farm on a hot August day. *Photo by Emil Teague.*

my favorite cut, while my wife loves prime rib," he shares as we walk around the property on a hot day. The cows seem content in the full sunshine and amble along, grazing. He continues, "Some of our customers like the offal, which are the internal organs and entrails. Other folks like the soup bone. We donate lots of soup bones to cancer patients, as I'm told the marrow makes a good broth."

New projects for Barley Beef include a new smart corral system, which will improve handling, reduce stress on the cattle and increase efficiency with herd management. Rastovich points to an area where the corral will be constructed. After a gate reads a radio-frequency identification (RFID) tag on the cow, the gate will open to the correct chute. Rastovich is also a computer programmer and helped design the system. He's particularly excited to see this in place for next season. A new marketing plan is underway, as well as voice-activated ordering. Rastovich knows he can't compete in price with big food suppliers but encourages restaurants to offer a Barley Beef burger for a small additional charge. He wants customers to make the choice and thinks that they'll taste the difference in quality. He also plans to increase the amount butchered each month, but not to the quantities of a huge corporate farm.

Rastovich is humble about Barley Beef's success and his longtime relationship with breweries. His years of cattle ranching experience and marketing come naturally to him. "For me, farming is kind of something that gets in your blood. You have a relationship with the land. People don't realize that what we do today...we don't reap the benefits until one to two years later," says Rastovich. "Much planning, work and nurturing went into the steak you're eating and enjoying right now."

DOME GROWN PRODUCE

Dome Grown Produce's farm is located just north of Bend in Redmond, Oregon. Amanda Benkert bought the twenty-acre farm in 2013 and now has two acres under cultivation. The land was originally part of a forty-acre horse farm, and the prior owners lived there for twenty years. It was overgrazed pastureland with broken fences and very little irrigation, but now, the farm is lush, with green grass sprouting up between raised beds.

Irrigation brought the farm back to life, and it's an idyllic setting with snowcapped mountains in the distance while butterflies flit around the flowers planted among the raised beds. "We started growing in the dome for ourselves, then started adding more and more raised beds every year. We just got the fence done last July," Benkert says and points to the newly constructed tall fence with the addition of chicken wire at the bottom. Benkert needs a tall, sturdy fence to control animals—like the plentiful populations of mule deer, marmots and pocket gophers—eager to eat her crops. Marmots are giant, burrowing ground squirrels the size of a cat, and it turns out they can easily climb smaller fences.

The farm is home to thirty-five crops, twenty-five chickens, three roosters, two Dexter miniature cattle and six American Guinea hogs, which will be butchered once they reach two to three hundred pounds. In the twenty-six-foot dome Benkert built in 2010, passive solar energy and under-soil heating tubes in the raised beds allow for year-round growing. Dome Grown Produce follows the same strict guidelines as certified organic farms, using sustainable and natural growing methods. The chickens have ample room to explore,

eating organic feed, and the farm supports biodynamic agriculture. This farming philosophy was introduced by Austrian philosopher Rudolf Steiner in 1924, and it encourages farmers to look at the mystical and spiritual perspective before planting and harvesting. The practice also focuses on soil management, crop diversification, composting, crop rotation, animal life and homeopathic and life forces.

Benkert is passionate about farming and growing good food. She was raised on a farm in upstate New York and has fond memories of helping out in the family garden. She became interested in botany and horticulture in high school, thanks to a science teacher. She pursued her interests in college, graduating with a degree in natural resource conservation. After relocating to Oregon from Colorado, she worked in a garden center and gained knowledge of farming in Central Oregon. As we talk, she cuts stalks of Swiss chard with a sharp knife and bundles them together for her CSA members. She says people should definitely give the leafy vegetable a try. "Swiss chard tastes more interesting. There are more ways to use it, plus it's really colorful. I cook it in bacon grease until it's soft and then add lemon juice," Benkert shares. She adds that kohlrabi is a funky-looking vegetable people should consider trying as well. It has a bulb encased with two layers of leaves, and the taste is similar to a cross between green cabbage and broccoli. Sliced thin, the raw bulbs are ideal for salads, and the leaves can be mixed in with other greens.

Dome Grown Produce's twenty-week CSA is structured market style, which allows members to choose their items and quantities each week. Bins and baskets display produce, making it easy to grab. Market-style CSA provides flexibility and the option to swap items and decreases waste. "I think there's more interest in market style," Benkert says. She hopes to increase membership each year. In late summer, she'll offer a special summer bounty CSA for five weeks. It's perfect for people who want to try a CSA and enjoy fresh produce at the height of growing season without committing to the entire season. Currently, Dome Grown Produce sells at the Redmond Farmers' Market, has a roadside stand and sells wholesale to Schoolhouse Produce and Pono Farm & Fine Meats. She may try to add another farmers' market next year.

Benkert received a grant through the Natural Resources Conservation Service (NRCS) and plans to build two small hoop houses for the 2018 season. They are more compact and use less plastic than building one large one, plus she doesn't want to obstruct the mountain views. Like their heavy-duty greenhouse cousins, hoop houses protect crops from hail and hard rain.

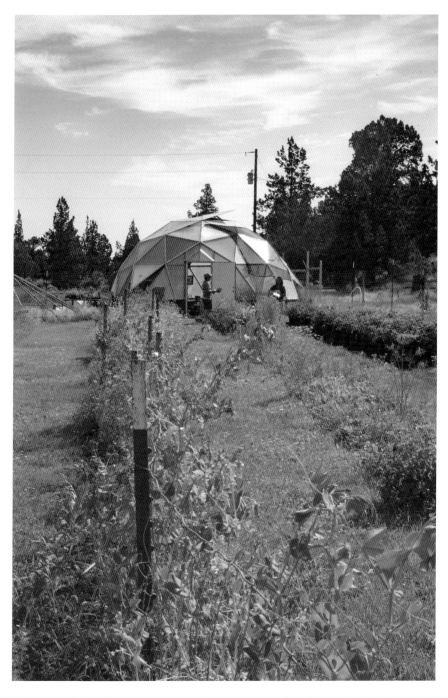

The twenty-six-foot dome uses passive solar energy and under-soil heated tubes in the raised garden beds. *Photo by Emil Teague.*

Amanda Benkert, owner of Dome Grown Produce. *Photo by Emil Teague.*

By trapping the daytime heat to keep soil and plants warmer at night, hoop houses extend the growing season by up to sixty days for frost-sensitive crops, thirty days on each end. She takes me on a tour of the existing hoop house full of eggplants, cucumbers and other vegetables. Benkert plucks a cucumber for me to sample—tasty, juicy and crisp.

Another project this summer is building herb boxes around the dome. The boxes radiate like petals out from the dome, and it will look like a sun when viewed from above. This project is in conjunction with the Willing Workers on Local Farms (WWOLF) through Central Oregon Locavore. Volunteers help farms with projects and, in return, learn about local food, farming and sustainability. Their prior WWOLF event occurred right before Benkert and her family moved onto the farm. Twenty volunteers constructed the dome frame and put up fencing for the large chicken run. She was six months pregnant and greatly appreciated the assistance.

While we walk along the outside beds, we talk about crops for new gardeners to grow. Benkert lists off kale, Swiss chard, squash, peas and beans. They're faster-growing vegetables, so gardeners feel successful. For this season, Benkert planted several new crops, including ground cherries (like a gooseberry crossed with a cherry tomato, wrapped in a tomatillo's papery case—very flavorful!), new varieties of cucumbers, Black Beauty tomatoes, purple-ribbed kale, potatoes in bags and sweet baby daikon radish.

Dealing with pests, weather, watering and bug pressure are some of the daily challenges, along with unexpected items like broken pumps and pipes. "Irrigation…I call it irritation. It's always a headache," Benkert laments. "Everything fluctuates so much. Farmers have to be open to change.… There's ups and downs with farming. We have to be prepared to change how we do stuff. People have this misconception of how easy it is, but they don't realize how tough and demanding it is. We're just trying to produce good, healthy food," she adds.

FIELDS FARM

We're here at 3,680 feet and subject to frost any day of the year....I remember frost on August 15," shares Jim Fields, owner of Fields Farm, the only farm located within Bend's city limits. Fields says the challenge is to protect the plants from frost and heat—sometimes both on the same day. Daily temperature swings of fifty degrees are possible and can stress crops. He talks about cauliflower plants that are delicious but difficult to sell due to their uneven appearance. In addition to the Central Oregon climate challenges, the local soil is very sandy and needs improvement to support the many varieties of vegetables grown each season. Fields mixes spent grain, picked up from local breweries, with his compost to enrich the fields. "Very little fertilizer is needed because of the addition of brewery waste. It improves the soil and helps retain moisture. We're able to push the soil water bank into April, which is a very good thing for the plants and soil microflora. If the brewery waste ends up in the landfill, it creates methane gas," Fields continues. "We also add coffee grounds from the local roasters to our soil, so if you think about it, our food from the farm comes from all over the world."

The home at Fields Farm was built in 1929 by the O'Keefes, a longtime Bend family. Over the years, many other families boarded their horses on the land, which was eventually subdivided and sold. When Jim Fields bought the ten-acre parcel in 1989, it was pastureland, nearly covered all with quackgrass, a noxious perennial weed. He began row cropping on five acres, and the farm started to take shape, using soil-building methods

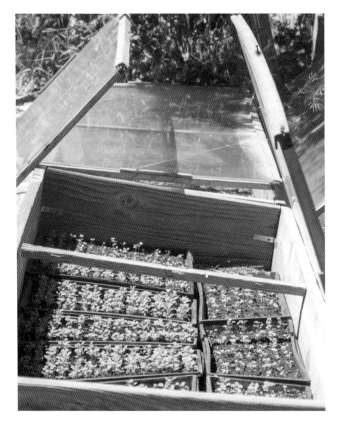

Left: Cold frames use solar energy and insulation to create a microclimate for plants. *Photo by Emil Teague.*

Below: Greenhouses and high tunnels at Fields Farm allow them to extend the growing season and experiment with different varieties of crops. *Photo by Emil Teague.*

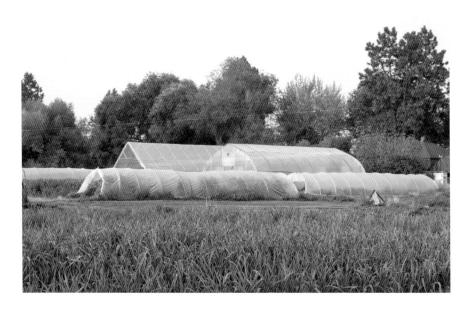

without pesticides or herbicides. Current crops include arugula, asparagus, beans, beets, specialty broccolis and cauliflowers, lettuce mix, ten varieties of potatoes and more. Globe artichokes are a specialty crop Fields began growing four years ago. They grow as perennials in warmer California fields but are harder to cultivate here due to the cooler weather, so they are planted annually. He provided food for members of the Dave Matthews Band when they performed at Les Schwab Amphitheater in 2014 and believes the opportunity arose because of the globe artichokes and the wide selection of produce from his farm.

The projected vegetable list for the 2018 CSA includes forty-three items, available through two sizes of boxes. My friend, a CSA member at Fields Farm, went out of town and generously gave me two weeks of their small box share. Pickup was easy, and the first week was filled with beets, celery root, carrots, potatoes, leeks, collard greens and red onions. The second week had several new items mixed in with many of the first week's selections, and the quantity of produce was plenty for my family of two. Fields Farm suggests sharing the large box with a friend or neighbor. The twenty-seven-week program begins in mid-May and includes an additional share at Thanksgiving. "With a ninety-day growing season, we need four, five or six successions to keep a steady supply for our CSA members," Fields expresses.

The farm also has produce for sale, bought on the honor system in the walk-up shed. A whiteboard lists items and prices, with produce in bins, baskets or the refrigerator. There's a notepad to write down your purchase and a green recipe box to leave payment. "We call us a drive-by farm. Come on by and see what we're growing," Fields says. Produce is available from mid-April through January, and they sell to restaurants, Agricultural Connections, Central Oregon Locavore and through booths at Bend Farmers' Market and NorthWest Crossing Farmers' Market.

Fields's first gardening experience was pulling weeds and digging up Jerusalem artichokes alongside his grandmother every Saturday in Oklahoma City. His grandmother had traveled to California to learn about organic farming and used her knowledge to successfully grow in the red clay soil of Oklahoma. She was an inspiration to Jim, and now he passes on his wisdom by offering farm consulting on land of ten acres or less. His staff are all aspiring farmers, soaking up twenty-eight years of experience from Fields as they work alongside him. Highly regarded in the farming community, he also built strong relationships with chefs in the area. Brian Kerr, executive chef at Deschutes Brewery & Public House, is a fan of the farm and raves about Fields's homemade sauerkraut.

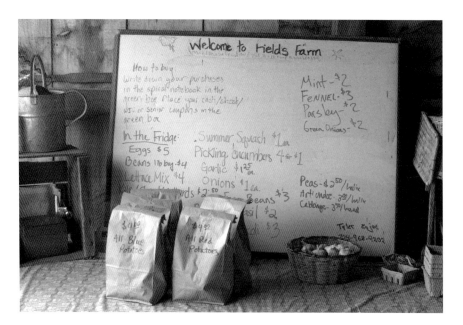

This whiteboard explains the honor system for buying produce at the walk-up shed. *Photo by Emil Teague.*

We discuss home gardening and crops an apprehensive gardener should try. "Potatoes, tomatoes or salad greens. Bok choy is amazingly easy to grow, too. Grow the thing you like to eat. Although financially, you should grow lettuce and greens. Start off with a three-foot row of seeds, and you'll have a steady supply of salad mix all summer, plus some to share with your neighbors," Fields advises. I make a mental note about this for my garden next year. He also shares some tomato-growing success from old-timers here in Central Oregon. Choose a short-season variety and pull a wagon filled with tomato plants out of the garage in the morning. Let them sit in the driveway on the north side until evening, and then return the wagon to the cooler temperature in the garage.

I shift our conversation to marketing and mention the photos of beautiful produce or videos of their booth at the farmers' market posted on social media. "One of the farmworkers does them all. It's a great way to communicate with customers, and it's the right thing to do," Fields says, appreciatively. Seeing photos of farm-fresh food spurs people into action, and with Fields Farm located right in town, it's easy to stop in. They also send out a weekly e-mail with a list of the produce available at the walk-up shed. Fields brings up different challenges in farming than I've heard from

other farmers. He talks about changing irrigation every eight hours, hiring staff and staying excited about farming. At the end of this season, two of the staff will leave to start their own farm, so he'll search for replacements. Fields ends with this final thought: "The economics of farming is not built into pay or the amount of hours you put into it. The greatest thing is feeding the healthiest food to neighbors…really good, healthy food."

GOLDEN EAGLE ORGANICS, INC.

Brian Lepore had no farming experience when he and his family moved from Indiana to Central Oregon in 2012. He was inspired to become a farmer and raise livestock after reading *Farming with the Wild* by Daniel Imhoff. The author travels around the United States and profiles farmers, ranchers, nonprofit organizations and others who farm using sustainable practices. After a two-year search, Lepore purchased two properties in 2014 and launched Golden Eagle Organics, Inc. (GEO). He and his family live on three and a quarter irrigated acres in Bend on the eastside. Their livestock in Bend includes ten sheep and three chickens. The other property is in Culver, about thirty-five miles from Bend. The seventy-seven-acre parcel has a barn, home and other outbuildings, along with scenic views of the Three Sisters volcanic peaks and Smith Rock State Park.

On my tour of the Culver property, Lepore opens the gate to the pasture, and the flerd (a flock of sheep and lambs together with a herd of goats) warily move away and graze at the far side. When deciding on livestock to raise, he chose goats and sheep because of their smaller size and ease in handling. As we walk around the pasture, Lepore points to fields growing organic and conventional hay. A pole barn has tall stacks of bales ready for delivery.

GEO is the only farm in Central Oregon raising organic lamb and goat meat. There are no herbicides, pesticides or synthetic chemicals used in the pasture where the livestock graze. Animals do not receive antibiotics or chemicals. For meat to be labeled and sold as organic, it must be processed by

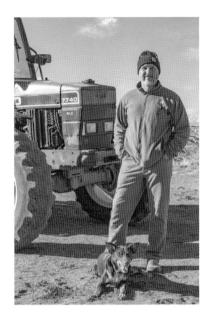

Brian Lepore and Pancho. *Photo by Emil Teague.*

an organic processor that keeps organic meat separate from non-organic. Lepore takes his livestock to Mohawk Valley Meats, a certified organic processor in Springfield, Oregon. About a week later, he picks up the wrapped and labeled meat. While most of their sales are direct to customers, GEO also sells to Central Oregon Locavore, Primal Cuts Market and Agricultural Connections. Currently, they sell more lamb than goat, but Lepore hopes this will change over time as more people try goat meat.

A common farming challenge is keeping equipment in good working order. Lepore bought a new no-till seeder for planting, but everything else was bought used and may cause headaches at inopportune times. He shares a story about using the hay accumulator grapple to load bales onto a trailer before making a delivery. After successfully loading one round of bales, he pushed reverse to pick up the next load, but the grapple stopped working. Lepore loaded the rest of the trailer with eighty-pound bales by hand. Finding dependable farmhands to help with hay during peak season is also a challenge since Lepore can't offer year-round employment. Watering the various fields daily, plus cutting and baling during hay season, results in fifteen-hour workdays. We shift our conversation to joyous moments, and he responds, "Lambing and kidding. Also, equipment working when you need it!"

SHEEP AND LAMBS

GEO bought its first animals in 2015. The farm raises two breeds of sheep, Suffolk and Katahdin. Suffolks are easily distinguished by their black heads and legs. They are known for their ability to gain weight rapidly and are raised primarily for meat production. Although shaggy, their wool is not as desirable for manufacturing. Suffolks tolerate a range of climates and

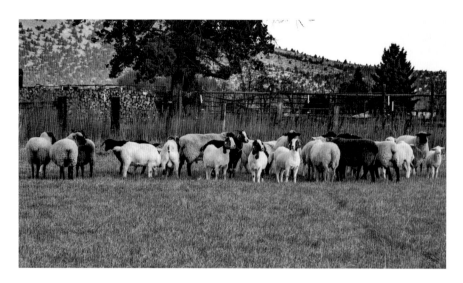

A flerd of sheep and goats. *Photo by Emil Teague.*

are a popular choice to crossbreed for meat production. They lamb in the spring, and Lepore moves the ewes to Bend, since they may require assistance.

Katahdin sheep grow hair instead of wool and do well in warm weather while also tolerating cold weather. Unlike the Suffolks and other wool-bearing sheep, they don't seek shade in the summer. Katahdins are hardy, low maintenance and known for their efficient meat production. Ewes have lambs in the fall and typically don't need assistance. Lepore arrives early in the morning and may be greeted with new lambs clinging to their mothers. A welcome surprise!

Sheep stay in the pasture from April to November, grazing on grass and other pasture plants. During the winter months, they eat organic hay and stay warm in the barn. To supplement their diet, all of the pregnant ewes eat organic grains. Currently, GEO has eleven Suffolk ewes, twelve Katahdin ewes and one Suffolk ram.

GOATS

Boer goats are known for their meat production, gain weight rapidly and have a high fertility rate. They do well in pastures, adapt to a range of

temperatures and graze on shrubs and weeds. Ranging in color from white to brown, or white with a brown head, Boers have long, pendulous ears. Goats are smart and nimble, with a good sense of balance. Since they easily climb fences to escape confinement, the fence is electrified. GEO currently has twelve does and one buck, either Boers or Boer crosses. Over the course of a few years, the number of goats will increase since the does often give birth to twins.

While most of the goats are skittish, one friendly goat wanders away from the flerd and lets me pet her. She is quite curious about my notebook, but after I assure her my "dry" notes would not be of any interest, she ambles back.

HAY

Sales of organic and conventional hay are approximately 85 percent of GEO's income. The acreage in Culver consists of organic and conventional hayfields, with a portion transitioning to organic. Lepore also leases sixty-five acres for conventional hay production and ten acres for organic production. To be organic, the farmland must be free of chemicals for a minimum of three years. Documentation is required. The process for organic certification takes approximately eight to twelve weeks and includes a site inspection. "I like the organic certification program and fully support it. It costs my farm about $1,200 a year, but I get back about 75 percent because of the cost-share program. But I do think some changes need to be made to accommodate small farms," says Lepore.

Since Lepore's first harvest in 2014, he has built a solid customer base, with occasional advertising on Craigslist. He uses a twenty-four-foot gooseneck flatbed trailer to haul up to nine tons to the valley or the coast. For smaller local hauls, a farm truck with a flatbed handles three tons or less. His delivery charge includes one person to either throw bales or stack it. The price for organic hay is 25 percent higher than conventional.

His yields aren't affected by environmental factors like heat or wildfire smoke. "If you're doing the watering right, you'll get good yields. Use water efficiently," Lepore advises. He points to an area outside the grazing pasture where an irrigation pipe from the pond is buried. A grant from the Natural Resources Conservation Service (NRCS) covered about two-thirds of the cost for the project, and Lepore was thankful for the financial assistance. GEO

Hay bales ready for delivery. *Photo by Emil Teague.*

uses irrigation water from the canals. Because of his organic certification, the irrigation company notifies him when it uses algaecide in the water. He does not use the irrigation water during this time and instead irrigates from the pond.

COOKING UP FUTURE PLANS

Both Lepore and Emily, his wife, enjoy cooking and share meal preparation duties for their family. Two years ago, he received a sous vide precision cooker, which cooks vacuum-sealed food in a precise temperature-controlled water bath. He uses it for roasts and steaks. Lepore says lamb shoulder chops are an underrated cut, full of flavor but easy to overcook. Lamb is higher in iron than chicken and fish. It's lean and rich in vitamins and minerals, including vitamin B12, selenium, zinc, niacin and phosphorus. Emily makes goat chili with bright, bold flavors using spices she encountered from living overseas. Goat meat is lower in fat than chicken and has more protein than beef. The meat is most tender when the goat is between one and four years old, weighing at least 110 pounds.

Barrio restaurant featured GEO in a "Meet Your Farmer" dinner with a menu including curried goat empanadas, pepita-crusted lamb chops and Mexican matzoh ball soup with lamb bone broth. Lepore also donated meat to High Desert Food & Farm Alliance for one of its events. "I'm inspired by the concept of the local food movement and inspired by the local food community," Lepore says. Through strategic and thoughtful planning, he is increasing marketing and awareness of the healthy, organic meat locally available. A booth at the farmers' market next summer is under consideration.

Lepore's goal is having his farm as diversified and practical as possible. By partnering with other farms to take over more animals at a time, he will decrease processing costs. Lepore plans to convert part of the organic hayfield to an organic grazing pasture. He also wants to substantially increase the livestock, with the majority being sheep. Lining the pond will reduce water loss, and pouring a concrete floor will keep the barn cleaner. He will convert all of his Culver pastureland to organic, while continuing to grow conventional hay on leased pastureland. Emily works full time in Bend. She plans to reduce her hours and spend more time on the farm, watching the lambs scamper in the pasture and enjoy the sunny weather.

GREAT AMERICAN EGG

O wners Justice and Anita Hoffman invited me out for a farm tour, and I was excited but apprehensive. I knew they sold eggs at the Bend Farmers' Market and also butchered chickens on their farm instead of taking them to a commercial processor. After spending several hours with the Hoffmans, I was fascinated by their farm and lost track of time while talking with them, touring the different pastures and watching them butcher chickens. They are passionate about farming and their flocks. "We're really clear about where our food comes from....Our chickens have a good life," Anita says. I saw firsthand how they raise poultry and pigs in a sustainable and thoughtful manner.

They did not start out to farm. Anita's only prior experience was helping her parents and grandparents butcher chickens, and it was not a fond memory. Before the Hoffmans bought farmland, they lived on Bend's westside, which is not an easy place to raise livestock. It was a book that kindled Anita's desire to farm. In *The Omnivore's Dilemma*, author Michael Pollan tracks four meals from cultivation to consumption. The Hoffmans did not want to be disconnected from their food supply and how it was grown. Starting small, they bought four egg-laying chickens, built a tractor house chicken coop and collected four eggs daily. They enjoyed having chickens and began researching broiler chickens.

When a friend offered the use of his pasture, they seized the opportunity to raise broilers. Soon, they found themselves butchering chickens in the field. A scalder and plucker mounted on a trailer gave them mobility and

sped up butchering, which made it possible to expand. The community of Powell Butte was nationally known for poultry in the early twentieth century and seemed the perfect place to set up, so they bought farmland there. Great American Egg sits on twenty-seven acres where they raise 400 egg-laying chickens, 450 broiler chickens and a litter of pigs. Powell Butte Canal runs alongside the property, providing irrigation from April 15 through mid-October. The Hoffmans grow hay and sell it in the summer, plus keep some on hand for wind breaks and bedding. Some years, they raise 50 turkeys for Thanksgiving, which quickly sell out. "It's cool knowing your turkeys are on tables. I love getting an e-mail from customers saying how good their turkey tastes," Anita says, smiling.

RAISING PIGS

Justice and I walk alongside the dirt trail next to the canal, heading for the pig enclosure. Earlier that morning, Justice and Anita moved the pigs to a new part of the pasture where they run about, exploring. The Hoffmans buy weaners at six to eight months old and keep the entire litter, runts and all. The white wire at the bottom of the fence is electrified, so the pigs respect the fence and try not to slip out. The pigs learn quickly and avoid the fence better when they're older. Justice says pigs run forward when scared, not backward like many other animals. They'll stay in this location for two months before an outside processer butchers them.

Great American Egg also offers butchering classes twice a year, where attendees can purchase a quarter, half or entire pig. Taryn Arnold, the farm intern, teaches the class, and attendees learn to break down the carcass. The Hoffmans sent Arnold to learn pig butchery from Portland Meat Collective, which offers hands-on classes. "Taryn has this kind and calm approach when teaching. She explains the process and offers solutions to people if they have a problem making a cut. She doesn't solve it for them and take over…. She'll suggest switching out knives or another technique. I really admire her approach," Anita explains. Arnold instructs attendees on the butchering basics, plus discusses cooking methods for each cut. Anita or Justice wraps up and labels the meat and writes down the cooking method the attendee chooses. "We want them to learn, then be able to butcher at home. Our hope is to not have a repeat person in class," Justice tells me. The classes often sell out, and the Hoffmans joke about it being a perfect date night for couples.

PASTURED POULTRY AND EGGS

After watching the pigs for a few minutes, we head toward the open pastureland where the egg-laying chickens reside. The Hoffmans buy young chickens in November through mail order and raise them as pastured poultry, a sustainable agricultural technique without indoor confinement. Three low white arched coops, affectionately called "super doops" by Justice, are moved once a week, allowing the grass to regenerate using the chicken manure as fertilizer. Wide swaths of lush grass show the regular progression across the pasture. Two super doops have laying boxes to collect eggs, and one super doop provides roosting at night. Water and feed stations are in abundance while chickens explore the spacious pasture. Three white roosters strut around, each with a bevy of hens trailing behind. Roosters are natural hunters and look for anthills or other places to forage. The hens follow them, work the area over methodically, scratching and pecking for insects, grubs and anything else they can eat. The roosters search for another area, starting the process over.

Part of the difference between pasture-raised and mass-produced eggs is from the natural forage, with the rest coming from the Hoffmans' custom-blend feed. They use locally sourced ingredients, with no corn or soy fillers. The egg-layer feed has triticale, a hybrid of wheat and rye that grows well in Central Oregon. Eggs are flavorful and the yolks intensely orange. Pasture-raised eggs have one-third less cholesterol, twice as much omega-3 fatty acids and seven times more beta carotene than conventional mass-produced eggs.

We talk briefly about predation and egg production. Eagles, coyotes and raccoons are typical threats but mainly kill to eat. Dogs do far more damage, shaking a chicken like a toy and moving on to the next one without eating what they kill. In addition, crows steal eggs, resulting in losses. Environmental factors such as hot summer days and wildfire smoke also affect laying rates by 15 percent. Colder weather and shorter days yield fewer eggs from the hens. Great American Egg doesn't use heat or artificial light, so eggs aren't available year-round. April and May are the high-volume months, with approximately 125 dozen eggs sold at the Bend Farmers' Market each week. Once summer solstice passes, egg production slowly decreases. By mid-September, they sell forty dozen eggs. Great American Egg has many loyal customers every week because of the high nutritional values in their eggs and the minimal environmental impact from sustainable practices.

RAISING BROILER CHICKENS

We walk over to the adjacent pasture to see the broiler chickens, housed in three doops (Justice's term for the smaller coops used on the meat production side of the pasture). Anita points out the healthy green grass, and it's easy to see the direction and path they've moved each day because of the regeneration. "That was two weeks ago. Look how it comes back strong," she says.

In 2008, Great American Egg became the first licensed poultry slaughterhouse east of the Cascade Mountains, with regular U.S. Department of Agriculture (USDA) inspections to keep its certification current. The Hoffmans process approximately two thousand chickens between Memorial Day and Halloween. Butchering takes place in a building about the size of a two-car garage. Justice and Lillian, their younger daughter, work together on the "dirty" side. Lillian takes chickens from crates and loads them into steel cones, head down. Justice makes a quick cut with a very sharp knife to kill each chicken. After letting the blood drain out, the chickens are attached to a dunker arm and lowered into the 145-degree scalder for approximately forty-five seconds. A quick rinse with cold water and then into the feather-picker machine. After Justice removes them from the feather picker, he cuts off their heads and feet and places the carcasses in ice-cold water, destined for the "clean" side. Anita and Hazel, their older daughter, process on the

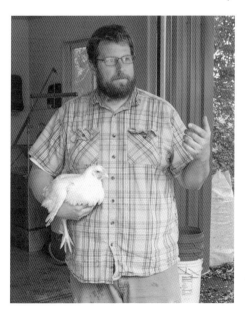

Justice Hoffman holds a broiler chicken while explaining the slaughtering process. *Photo by Emil Teague.*

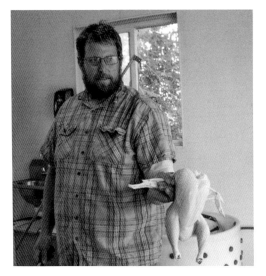
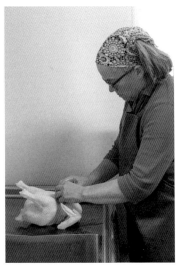

Left: A live chicken quickly becomes a freshly plucked chicken. *Photo by Emil Teague.*

Right: Anita Hoffman inspects each chicken on the outside for errant feathers or broken wings. *Photo by Emil Teague.*

"clean" side. They remove the crop (food pipe) and preen gland and then cut into the body cavity to remove organs. Anita can process a chicken in approximately thirty seconds. "I'm one of those people who likes to get the job done....That's why I think production work appeals to me. Butchering is like meditation," Anita expresses. While working together, Hazel cranks up the music, and they sing and laugh. In less than three hours, fifty-two cleaned chickens are chilling in ice water, awaiting the final step of bagging and storage in the refrigerator.

Eager buyers show up the following day to pick up fresh chicken. "We're not mainstream chicken," Anita says as she talks about their customers, who love them for their production ethic or other reasons. They aren't selling to the customer who compares their prices to mass-produced chickens from huge farms. Anita shares, "Just knowing that we're feeding people really good food is my favorite thing about farming. And that we can do it."

MAHONIA GARDENS

Carys Wilkins and Benji Nagel own Mahonia Gardens, named after the Oregon grape, a species of flowering plant with clusters of dark blue berries, native to western North America. The one-acre market garden is located in Sisters, Oregon, population 2,055. The elevation is 3,200 feet with an annual rainfall of fourteen inches. Running a successful farm in this climate is challenging, yet they do it well, with a passion for the area and plenty of community support. Wilkins and Nagel met while studying environmental science during college in southern Oregon. After apprenticing on separate farms in Sonoma County, they moved to Sisters and launched a Kickstarter campaign, raising over $9,000 to start Mahonia Gardens. "Benji grew up here in Sisters, and that definitely helped. Everyone has known him since he was five years old. We started the farm with no debt and doubled our income every year the first three years," says Wilkins. Nagel nods his head and adds, "It was an amazing process, not only in money raised, but it created a buzz, and we built a customer base. I don't think we could've gone just anywhere and been so successful."

The farmland was formerly a cattle and horse ranch, raising beef for Bronco Billy's Ranch Grill and Saloon (now Sisters Saloon). Wilkins and Nagel lease the land from a longtime Sisters family, the Tehans, who have owned it for thirty-two years. Students from Sisters High School helped transform the former roping arena into garden beds the first season by clearing out rabbit brush and hauling dirt. "The students were excited to learn, and they're really getting into local food," says Nagel. Each year, a

Sisters High School students helped prep the former fenced-in area for garden beds. *Courtesy of Mahonia Gardens.*

new class of students comes out to the farm, helping with a variety of tasks. Wilkins says gardening and local food were not topics when she was in high school. She's happy to host students and share her knowledge of farming with them.

Mahonia Gardens is farmed using hand tools, with the occasional assistance of a small rototiller, although they are gradually moving to a no-till system. There are no pesticides, herbicides or chemical fertilizers used. They grow forty crops in four-foot-wide intensive permanent beds, with narrow walking paths to maximize growing space. "Bok choy is my favorite vegetable to grow," Nagel says excitedly. "It's one of the most amazing vegetables. It's so juicy, and you can eat the raw stalks dipped in peanut butter." Every year, they experiment with new crops to see what grows well and is popular with customers. In 2017, they expanded their selection of cherry tomatoes, taking full advantage of the extended growing season in their high tunnel. I ask what crop they're most excited about this season. Wilkins gestures to the flourishing bushes and responds, "Our raspberry patch." Benji chooses Padrón peppers.

Their CSA program is divided into seasons, starting with four weeks in the spring and culminating during Thanksgiving week. Currently, they have forty CSA members, with the majority in the Sisters area. They also sell produce through Agricultural Connections and Melvin's, a natural health food store in Sisters.

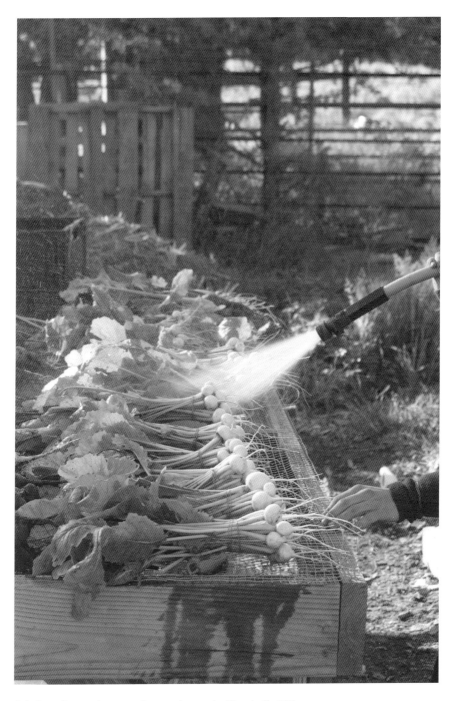

Salad turnips receive an early morning wash. *Photo by Emil Teague.*

Carys Wilkins and Benji Nagel, owners of Mahonia Gardens. *Photo by Emil Teague.*

Their booths at NorthWest Crossing Farmers' Market and Sisters Farmers' Market overflow each week with different offerings. Wilkins says the first couple of years at the market, they had conversations about the higher price of their produce since many shoppers were used to prices at conventional supermarkets. Now in their fifth year of farming, topics range from types of crops to education on growing practices, and prices are no longer the sole topic. She notes that they know most of the people who visit their booth at the Sisters Farmers' Market, and everyone feels comfortable asking questions. Wilkins cuts up vegetables for shoppers to sample, often choosing vegetables that shoppers may not have seen or tried. They encourage people to try fennel, a bulbous-base vegetable with long stalks and a flavor similar to anise. The anise flavor lightens when cooked. She suggests people stock up on garlic for the winter, which they cure by hanging in the shed, allowing for air circulation.

They both enjoy spending time in the kitchen; Nagel used to cook at the Open Door restaurant in Sisters. "In the summer, we take whatever we've harvested and make something tasty. We don't let anything go to waste," Nagel says. They also make large quantities of soup with seasonal vegetables, freezing it so they can enjoy it year-round. For their CSA weekly pickups, they research recipes online and include them in the boxes.

In the winter, Wilkins teaches yoga and Nagel plays music in several bands. Both love to backpack, cross-country ski and enjoy nature. They stress the importance of having a life outside the farm. Upcoming plans include growing inward rather than outward, since space is limited, and continuing to improve sustainability. Wilkins and Nagel want to continue farming by hand and have extra time to tend to crops. Even with the long hours in the summer and the reality of running a farm, it's a labor of love.

NOVICKY'S FARM

When Justin Novicky transplanted five hundred tomato plants into raised garden beds, he talked to each one, thanking them for what they would provide. He plays reggae music every day for the plants and says they sense his positive attitude when he enters the greenhouse. "I have genuine respect for Mother Earth. I give these plants my energy, and I take good care of them. They are truly grown with love," Novicky shares. Novicky's Farm grows eight varieties of tomatoes, including Big Dena Beefsteak, Cherokee Purple Heirloom, cherry tomatoes and Indigo Rose Purple tomatoes from Oregon State University. He also grows Blue Dwarf kale, tomatillos and basil and collects eggs daily from thirty chickens. In 1909, Novicky's great-grandmother from Slovakia brought sweet onion seeds sewn into the hem of her dress to the United States. He is proud to cultivate and grow heirloom sweet onions from seeds passed on through many generations of his family.

Victoria Roth, a well-respected vegetable farmer, mentored Novicky on her farm. They focused on growing tomatoes, and he fell in love with the process. At the end of his second season with Roth, her farm was sold, and Novicky searched for a new property. Brian and Terese Jarvis, longtime Bend residents, read about his situation in *The Bulletin* and reached out to him. The Jarvises leased him a nine-acre parcel near Cline Falls, just outside Bend. "I give thanks to Brian and Terese for keeping my dream alive….I'm just so thankful. I'm fully embracing the farm life," Novicky says gratefully. He pays it forward by mentoring a student from Marshall

Tips for trimming and cultivating the tomato plants. *Photo by Emil Teague.*

High School who comes to the farm weekly to learn about farming. He also enjoys giving tours to families. "Some don't know where their food is coming from. I love teaching kids about growing tomatoes. They can see it, taste it and appreciate it," he explains.

Novicky launched a GoFundMe campaign, raising over $12,000 toward the construction of a three-thousand-square-foot greenhouse on the parcel. Donations of wood from demolition of Skjersaa's Ski Shop and rebar for the raised beds came from his neighbor Paul Spezza, a general contractor. Novicky laughs, "I never thought I would build something. This is all a gift. I want to do the best I can, and I love it." He looks truly blessed as we walk around the tidy greenhouse with fans circulating on a sweltering summer day, and he points out the different varieties of tomatoes clinging to the trellises. The tomato seeds were planted in February, about six weeks later than usual, due to greenhouse construction. With careful nurturing and monitoring, he was able to harvest in July. His goal is to prolong the yield to have fresh tomatoes at Thanksgiving. We stop in front of a tomato plant taller than Novicky. "There's no one else here focused on growing tomatoes, so I felt it was my calling. People don't believe me when I tell them I'm a tomato farmer. They think tomatoes can't be grown here. Now, it's a little challenging, since today is supposed to be one hundred degrees.

On a hot day, there can be a temperature swing of fifty degrees. With that kind of fluctuation, it's hard on the tomatoes, and they can easily split," he says worriedly. Preferred temperatures are between forty-five and ninety-five degrees.

Other common challenges in Central Oregon are the sandy soil, lack of water and short growing season. With proper soil amendment, regular watering, protection from unexpected frost and choosing the right variety, tomatoes will flourish. Some early season tomato varieties will produce fruit in fifty-five days. Next year, Novicky plans to build another greenhouse, which will bring him back to the capacity he previously had at Roth's farm. In addition to the new greenhouse, Novicky plans on adding an automated watering system and an upgrade in ventilation. He is moving toward a completely organic operation. Plants in two of his tomato beds and the tomatillos are organic this year. The other beds use the Mittleider Garden Method he learned from Roth, which uses vertical growing and supplements the plants with thirteen trace micronutrients. While Novicky

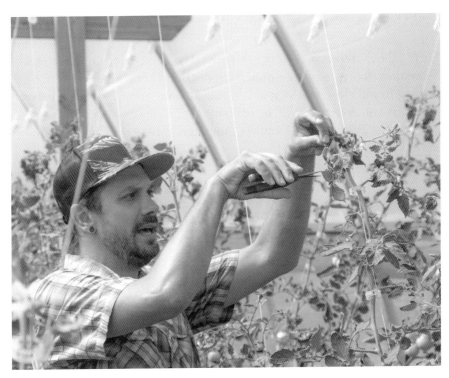

Justin Novicky, owner of Novicky's Farm, trims branches so they don't infringe on neighboring plants. *Photo by Emil Teague.*

worked with Roth, he did extensive research about gardening. "I know I'm learning. I'm always willing to get insight from others, and I love constructive criticism. Farmers are very open here. They want to help and love to share information. I want to do my best," he expresses.

With a background in the hospitality industry and having lived in Bend for seventeen years, Novicky already knew many of the chefs in town. Last year, he set up a farm stand on the westside in front of Baldy's Barbeque restaurant. Ariana Fernandez, chef and co-owner of Ariana Restaurant, stopped by and began buying from him regularly. Novicky shares a story about a couple enjoying his tomatoes at Ariana Restaurant and then going home to look up Novicky's Farm online. They came out for a farm tour to see where those delicious tomatoes were grown. It was a memorable and rewarding moment for Novicky. "When you harvest the fruit, taste it and hear compliments…your hard work really pays off," he says enthusiastically. He also sells tomatoes to Sunriver Brewing Company, Tumalo Farm Stand, Central Oregon Locavore and Deschutes Brewery & Public House. "The restaurants understand if harvest is a little low sometimes. They know about this climate and have an understanding of growing. I'll continue to build it up more and increase quantities," says Novicky. "I grew up in Crescent City, California, and would come to Bend to visit. When I was a little boy, I ate at Deschutes Brewery & Public House. Now, I'm growing tomatoes for them." He grins as he thinks about how it has come full circle.

TUMALO FISH AND VEGETABLE FARM

The greenhouse and Quonset hut of Bob Camel's operation are easy to miss, tucked into tall green grass and spindly juniper trees. There's no signage other than the address number posted on a green-and-white sign, and none of the tractors and other equipment common with most farms and ranches sit out, dirty from use. Bob greets me in the short gravel driveway and invites me in for a tour.

RAISING FISH

Just inside the sparsely lit Quonset hut, barramundi swim lazy circles in the clear water-filled round tanks, approximately four feet in diameter. The fish are a white-fleshed species native to fresh and brackish waters from northern Australia to Southeast Asia. Behind the round tanks are orderly rows of long fiberglass tanks, with a network of catwalks for easy access. Large schools of barramundi swim in the brackish-colored water in the tanks. "The pellet food turns the water this color. Interestingly enough, the color is similar to their native water in Australia, and it keeps the fish calmer," Camel explains. He feeds them premium sterile pellets to ensure no diseases or parasites are introduced into the tanks. During feeding time, fish race up and down the tanks as he walks by throwing out pellet food. They're capable of facial recognition and will swim away if strangers walk down the catwalk without Camel.

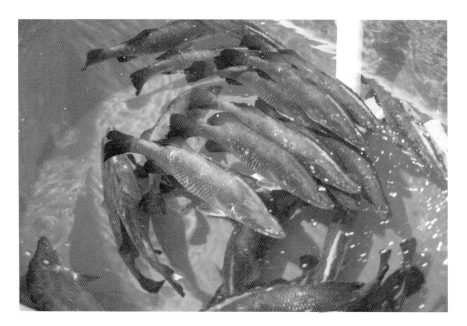

Barramundi swim in circles in a round tank. *Photo by Emil Teague.*

"I chose barramundi because of their tremendous health aspects," states Camel. Their taste is similar to halibut and grouper, plus it has a comparable amount of omega-3 as king salmon but 50 percent less calories. The fish are disease-resistant, and Camel never uses any type of drugs or products containing toxins or heavy metals. He tests the water and the fish constantly as part of his strict quality control process. The fingerlings are ordered from an Australian aquaculture company. An eight-ounce package holds five thousand fish. Barramundi grow rapidly and will weigh two to three pounds in less than eight months. Once the fish reach market size, Camel moves them to the round tanks with clear water for five to seven days, which improves their flavor. He samples several fish a week and finds they taste like wild-caught fish, not farm-raised.

The fresh fish production part of the operation is only part of the aquaculture aspect Camel designed. He also converts the fish waste (their excrement) to make fertilizer for the greenhouse operation. A current in the long tanks carries the fish waste to a drain and from there to a drum filter. Solid waste and water are separated by the filter, and the water passes through a biofilter, which converts the ammonia into nitrites and then into nitrates, using aerobic bacteria. Ammonia comes from fish respiration, urine and other dissolved solids not separated by the filter. Byproducts such as

ammonia and nitrites are toxic to fish in any amount. Next, the water passes through ultraviolet sterilization followed by oxygen injection and is returned to the fish tanks.

Solid waste is sent to three concrete digester tanks located in the ground outside the hut. The first tank contains anaerobic bacteria to start breaking down the waste. The second tank has aerobic bacteria and ambient air. By the third tank, the nutrient water is clear and odor-free, ready for plants in the greenhouse. Camel tests the water regularly and occasionally adds iron or potassium. Otherwise, very little is added to the nutrient water before going to the greenhouse. "This is a hybrid form of aquaponics. I'm probably the only certified organic operation like this," Camel says proudly.

Upcoming plans include marketing and selling the live fish to local restaurants. He took fish to a downtown restaurant in Bend and received positive feedback. With a reliable outlet for the fresh fish, Camel can double the number of fish he raises to system capacity, producing twenty-five thousand pounds per year. He plans to make his own feed for the barramundi and is working on a more efficient filtration system to cut down on the amount of added fresh well water needed to keep the system in balance.

GROWING TURMERIC AND GINGER

Long horizontal troughs overflow with turmeric and ginger plants in the eighty-five-degree, 2,200-square-foot greenhouse. It's challenging to walk between the troughs or see above the plants. Planted in white pumice, a lightweight biodynamic growing medium, plants grow taller and produce higher quantities because of Camel's process. Earthworms, springtails and spiders thrive in the pumice by breaking down the organic matter from the old roots and seeds. Camel scoops up a handful of pumice, and it smells just like rich, earthy soil. The opaque greenhouse cover creates even, diffused lighting. The plants receive more light in this shadow-free atmosphere, and with 70 percent relative humidity, it doesn't take long to break a sweat while Camel continues the tour. With lights on timers, plants receive a minimum of twelve hours every day. An overhead curtain automatically closes if the outside temperature drops to sixty-five degrees, retaining the heat in the greenhouse. Radiant floor heating keeps plant roots warm, and evaporative cooling in the summer keeps temperatures

from getting too hot for the plants. Using a fully automated system, six different watering zones fill, drain and fill again with the nutrient water four times a day. It takes seven hundred to eight hundred gallons of water to fill three beds, using gravity to drain back to the storage tank in twenty minutes. The plant roots are stable in the pumice and absorb nutrients from the water in a cross between dirt farming and hydroponics. In the controlled environment, Camel doesn't have the usual challenges of weed control, pests and daily physical strain.

Camel buys red and red-yellow varieties of turmeric seed from Hawaii. The red-yellow turmeric is a hybrid with increased medicinal value and is more bitter, while the sweeter red variety is preferred for juicing. One trough is planted with ginger, with turmeric plants filling the rest. When he first planted two years ago, the demand was higher for ginger, but it has shifted to turmeric over time. Each turmeric trough yields three hundred pounds when harvested after the plants mature at ten months. This year, Camel will harvest three to four thousand pounds of turmeric. His customer base includes individuals, Agricultural Connections, Central Oregon Locavore and wholesale companies. He sells twenty-five pounds of turmeric a week locally. Market demands are highest from October to January, so he sells

Bob Camel, owner of Tumalo Fish and Vegetable Farm, stands in front of tall turmeric plants. *Photo by Emil Teague.*

large quantities to wholesalers during this period. Harvesting, drying and packaging two hundred pounds of turmeric takes one day with two people working. The entire plant is taken out when harvested, so Camel staggers plantings to have mature plants for harvest all year long. He also produces and sells value-added products such as pickled turmeric and ginger. Camel advocates the numerous health benefits of turmeric. His research shows it reduces inflammation and is more effective than ibuprofen, which has side effects. He drinks straight shots of turmeric in the winter.

Camel plans to purchase land and build additional greenhouses, each dedicated to one crop. Once he farms fish at full capacity, the nutrient water will support three to four greenhouses. This winter's crops include basil, lipstick bell peppers, strawberries and cucumbers in troughs above the turmeric, providing produce during the off-season. Growing bell peppers vertically will take full advantage of the light in the greenhouse. He may also grow brahmi, also known as water hyssop, a traditional native herb from India. His farming philosophy is to grow plants for the medicinal value, and he doesn't want to compete with local farmers. Camel has clearly found his niche in the market and enjoys that aspect of the business. Now his operation thrives, and he's ready to increase production and marketing and share his love of farming.

CREATING OPPORTUNITIES

The entire operation is impressive, with extensive engineering and automation on both sides. Two hours a day of work by Camel or his part-time employee are enough to keep fish and plants tended. "I took my time to develop this operation, and I was willing to do what it took," he says. All the systems have backup generators. There were a few situations before the generators were installed, and they ended with a trip to the dump. But he looks at these as learning opportunities.

"In this business, you have to be good at everything—raising fish, horticulture, mechanically inclined and you have to do the research," Camel advises. His work experience includes house building and boat building. He had never planted a garden or tried any type of agriculture until this adventure in aquaponics. "When I moved here twenty-one years ago, my intent was to be a fish farmer and a builder. I did hours and hours of research. I also built these two buildings and helped with the electrical and

the plumbing. Now, I'm totally a farmer, but a different kind of a farmer," Camel says proudly. "In everything I do, it's not just growing food. It's the nutritional value of the plant. It's about providing products that improve people's health. I really love doing this. I'm never so happy as when I come out here. What we do as fish farmers, when done right, is good for people and good for the planet."

BEGINNINGS AND ENDINGS

During the research and writing process of this book, one farm harvested its last crop, while another broke ground for its first. While several farms in Central Oregon have been around for many years, newer farms in the last five years have entered the marketplace, providing fresh, healthy nourishment.

BOUNDLESS FARMSTEAD

Cars line the road to Megan French and David Kellner-Rode's new farm in Alfalfa, thirteen miles east of Bend. They invited folks out to see their farm and celebrate with a full lineup of festivities, including a community art project, cider pressing, lawn games and a pop-up farmers' market. Boone Dog, a wood-fired pizza oven food truck, provided food, while the Little Noise Makers played lively tunes in the barn for the crowd. During a break in the music, Megan and David revealed the name of their new farm: Boundless Farmstead. With help from David's parents, Megan and David will run the farm and live in one of two homes on the property. Boundless Farmstead consists of twenty acres, with four and a half ready for crops. On the farm tour, David talks passionately about upcoming plans. I gaze at the empty, flat farmland and easily imagine it full of crops in the middle of the summer. He points to a row of freshly turned earth planted with four varieties of

Welcome sign at Boundless Farmstead posted at the end of the driveway. *Photo by Emil Teague.*

garlic. Parked nearby is a new tractor with traces of dirt clinging to the tires. Many farms have old tractors, and a new one is a rare sight outside of a dealer's lot. Their old tractor was unreliable and costing too much time and money to fix, so a replacement was needed to prepare for the coming season and will serve them well for many years.

One pasture has broiler chickens in a moveable coop, which protects them from hawks and owls. A flock of egg-laying chickens and one turkey scratch the ground for bugs and explore the fenced-in area. A covered chicken coop provides a protected place for daily egg collection and roosting at night.

Megan and David worked for Jim at Fields Farm, and now they're bringing all their experience to Boundless Farmstead. They have contracts set up already with Jackson's Corner, 123 Ramen and Bend Pizza Kitchen. A booth at the Bend Farmers' Market is confirmed as well. Their new farm will bring in more locally grown produce to the Central Oregon community, and it's exciting to follow their progress and support them.

RADICLE ROOTS FARM

Owner James Berntson and I wander around the perimeter of perfectly straight rows of carrots, kale, romaine lettuce and more. We come up alongside the radish row, and he plucks a French Breakfast radish out of the ground, brushes off the dirt and hands it to me. It's bright white and oblong shaped, with a pleasant spiciness. Berntson focuses on baby greens and specialty roots in permanent beds. Most of the work is done by hand, and there are no pesticides, herbicides or synthetic fertilizers used. He uses row covers to give transplants a head start and grows cucumbers, heirloom tomatoes and cherry tomatoes in one of two unheated greenhouses, which trap heat even on cool nights. The fans spin on high when we walk in, and

the distinct, sharp tomato aroma takes me back to my grandfather's garden in Cincinnati. Growing these crops trellis style allows for easier harvesting and more plants in the beds. We wander over to the next greenhouse, and he shows me trays of pea shoots and sunflower shoots. After ten days, they are harvested and sold to local restaurants.

Berntson and Don Schack, longtime Bend resident and owner of Plainview Community Gardens, met at a High Desert Food & Farm Alliance conference. Schack became a mentor and friend to Berntson, who was new to Central Oregon and exploring options to work on a local farm. Schack had acreage, buildings and equipment to lease. After an agreement was formed, Berntson established Radicle Roots Farm on three-quarters of an acre twelve miles northwest of Bend. "Everyone is willing to share knowledge.

James Berntson, owner of Radicle Roots Farm. *Photo by Emil Teague.*

An abundance personality…the more you can produce, the more there is. It's an exciting time to be a farmer. We're on the cusp of a big revolution, and there's so much innovation for small farmers," says Berntson. "Support your community and don't live in a food desert. Local food tastes better, fresher and lasts longer."

"This is a unique climate with extreme temperatures. The air is really dry and arid, which makes it hard to germinate. We have a short growing season with a late frost in the spring," Berntson says. He's a first-generation farmer who grew up in Snohomish, Washington. Now in his third season, Berntson knows many tips and tricks to successfully grow crops here. We talk about lessons learned from his experience so far. "When you first start a farm, you romanticize about it, but there's so much more to learn. Payroll, taxes, structuring your company…the whole business side of it," shares Berntson. He also built relationships with the chefs at Barrio and Jackson's Corner, delivering fresh produce twice a week. Agricultural Connections (AC) negotiates contracts between farmers and restaurants, and Berntson has several set up for his salad mix, pea shoots and lettuce varieties. He believes there's huge growth potential in the restaurant scene, and it opens up the floodgates for local farmers. In addition to selling through Central Oregon Locavore, he has a booth at the NorthWest Crossing Farmers' Market.

On October 19, 2017, Berntson and his girlfriend packed up a U-Haul trailer and headed for Snohomish to be closer to family. He will establish a new farm there. It was bittersweet to see them leave. On my visits to the farmers' market for produce and fruit, I would also introduce myself to farmers. Berntson was always smiling, talking with other vendors and enthusiastically greeting people at his booth. He was the first one I met and very receptive to my book. He immediately invited me out for a tour, and I appreciate the time he spent with me one chilly early morning. Since leaving Central Oregon, Berntson has broken ground, plowed and tilled in preparation for spring planting. I wish him much success in his new adventure!

SHOPPING SEASONALLY

Farmers' markets provide easy access to healthy, fresh food while also building relationships between customers and farmers. Each market operates under individual guidelines and is unique in its offerings. Farmers benefit financially by selling directly to the customer, and they have an opportunity to educate customers on growing practices, introduce new vegetables and share tips on preparation. The majority of the produce is harvested that morning and travels less than fifty miles. However, there are a few select vendors who travel from the Portland area or Willamette Valley and sell berries, pears, peaches, watermelon and more. Due to plentiful rain, warmer climate, fertile soil and a longer season in those areas, farmers have much success growing those crops.

The food at the farmers' market is fresh, full of flavor and nutrient-dense. Buying from farmers at the market puts more money in their pockets, which goes back into the farm and crops, and hopefully, the level of engagement is beyond transactional; you're also supporting the local community. I generally invite a friend to go to the farmers' market with me. We buy local produce and enjoy lunch at one of the restaurants located near the farmers' market. If I go by myself, I buy a coffee and pastry from a nearby café. During the season, farmers' markets operate every Tuesday, Wednesday, Friday and Saturday, so it's convenient to buy locally grown food.

Many farmers' markets accept Supplemental Nutrition Assistance Program (SNAP) benefits and Women, Infants and Children (WIC) Nutrition Program vouchers. The amount of SNAP dollars used at farmers' markets has almost tripled over the last five years.

NORTHWEST CROSSING FARMERS' MARKET

Overflowing pints of golden raspberries, blackberries and blueberries catch my attention as I enter the NorthWest Crossing Farmers' Market. The berry booth is always my last stop so I can avoid hauling my flat of twelve pints all over the market. My first stop is always at Bontà Gelato for a scoop of toasted coconut. It's a refreshing way to start my day, even at 10:00 a.m. My first visit to the NorthWest Crossing Farmers' Market was in 2010, with a handful of booths selling goat meat, cheese and honey. Now, the market boasts eighty booths selling produce, locally raised meat, handcrafted jewelry, fresh flowers and more. There's live music every week on a stage surrounded by linen-covered tables with plentiful seating. Students from String Theory Music busk near an entrance to the market, and a petting zoo is a welcome addition. Oregon State University Extension Service Master Gardeners offers tips at its booth, and several nonprofit organizations offer information about their programs. The market is located within a traditional neighborhood development, and many families walk or ride their bicycles with shopping bags in hand for purchases.

NorthWest Crossing Farmers' Market welcomes locals and visitors from June through September each summer. *Photo by Emil Teague.*

BEND FARMERS' MARKET

Great American Egg's whiteboard displays prices at the Bend Farmers' Market. *Photo by Emil Teague.*

"Look at these gorgeous garlic scapes!" I hear a shopper tell her friend as she waves two bunches of stalks in the air. Scapes are the flower buds of a garlic plant and can be used in the same way as garlic in any recipe. I stroll down Brooks Alley on a sunny Wednesday afternoon, hearing other exclamations about colorful produce and offerings. Booths line the alley, allowing ample room for locals and tourists to peruse the market. Chefs from downtown restaurants pick up produce, planning the evening's special as they walk back loaded with fresh produce to their kitchens. A market bell rings at 3:00 p.m. to signify the opening of the market, and vendors greet their first customers, patiently lined up. The year 2017 is the twentieth anniversary of Bend Farmers' Market, and it was the first market in Oregon to launch a Farm to School program. Market products are incorporated into the Bend-LaPine school lunch program, and students enjoy fresh local food while learning about nutrition.

Here are a few tips when going to a farmers' market:

- Bring cash. Not all vendors accept credit cards, and cash is fast. I make a note to stop by the bank a few days before the market so I'm ready to go.
- Arrive early if you're shopping for items like eggs or tomatoes, which sell out quickly.
- Bring reusable shopping bags. Toss in your goodies and continue shopping. I throw my wallet in the bag so I have both hands free to squeeze a peach, snag a sample of a baguette from Jackson's Corner or grab a package of pork chops from the Great American Egg booth.
- Make a list, but be flexible. Sure, you have a hankering for Caprese salad for dinner, but maybe tomatoes aren't in season yet. Know what's in season and plan your menu accordingly.

- Walk around the farmers' market first to see what's available and let the offerings inspire your cooking. As some of the chefs advise in this book, try something new and ask the farmer for a sample or preparation tips. Everyone has a favorite recipe using seasonal produce, and they're happy to share it with you. As you read this book, many farmers suggested bok choy. It's a wonderful Chinese cabbage full of nutrients and vitamins.
- Enjoy the sights, smells and bounty at the market. See the smiles and feel the energy. Take delight in your time outside!

Fun fact: there are over 8,600 farmers' markets in the United States. When you travel to different cities, stop at a farmers' market and pick up local produce. You'll see different kinds of produce for sale depending on the location and time of season. I love going to the farmers' market in Eugene, Oregon, which runs from April to November. The Willamette Valley growing season is longer and warmer than in Central Oregon.

COMMUNITY-SUPPORTED AGRICULTURE

For over thirty years, Community-Supported Agriculture (CSA) has connected local farms with customers for fresh produce and other products. Farmers offer a set number of CSA shares to the public, and money is paid in advance. This helps the farm with operating capital costs and aids in planning for the season. Members enjoy fresh, local food throughout the growing season, and they develop a relationship, sharing risk and the bounty of crops. The North American movement was begun in 1985 by farmers Robyn Van En and Jan Vander Tuin. They were influenced by Austrian Rudolf Steiner's work in biodynamic agriculture. In 1988, Van En sold a two-dollar pamphlet titled *Basic Formula to Create Community Supported Agriculture*. Indian Line Farm in Massachusetts and Temple-Wilton Community Farm in New Hampshire were the first two CSA farms, and they're still going strong today. According to the 2012 census, there are 12,617 CSA farms in the United States, with the majority located in California. Some farms have events for members during the season, allowing them to harvest produce or tour the operation.

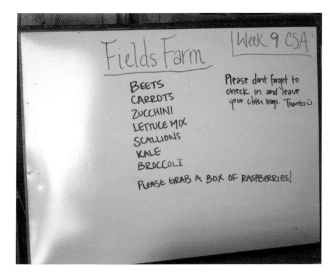

Fields Farm — Week 9 CSA

BEETS
CARROTS
ZUCCHINI
LETTUCE MIX
SCALLIONS
KALE
BROCCOLI

Please don't forget to check in and leave your cloth bags. Thanks ☺

PLEASE GRAB A BOX OF RASPBERRIES!

Left: Produce for CSA week 9. *Photo by Emil Teague.*

Below: CSA weekly produce picked up at the end of September from Fields Farm. *Photo by Sara Rishforth.*

The average cost of a CSA share is twenty dollars a week. CSA boxes come in a variety of sizes to fit your family and cooking habits, and structure varies with each farm. Market style allows members to choose their items and quantities each week, while farm staff selects items and quantities in a traditional CSA. Farmers may also team up and offer other items for sale, such as chicken, eggs or cheese from neighboring farms. Another option available at participating farms is to work on the farm for a set number of hours for a discounted CSA share. Typically, a CSA begins in early summer, and some continue until Thanksgiving with a box of root

vegetables. Farms drop off the boxes to several locations around town so it's convenient for members to pick up. Consider asking your friends who are CSA members what they like or don't like about their membership. Feedback is always helpful when choosing a farm.

Some important questions to ask the farm include:

- How long have they been farming?
- What are the pickup location(s) and days?
- What is the style of CSA?
- What is included in the CSA (vegetables, fruits, grains)?
- What are the box sizes?
- What are the options if you're out of town?

"I think a CSA is mostly greens and lettuce mix most of the time," a friend said as we talked about splitting a CSA membership last summer. During my research for this book, I found that's a common misconception. Following is a CSA weekly summer share list from Carys Wilkins and Benji Nagel, owners of Mahonia Gardens.

Week 1	Salad mix, bok choy, beets, market turnips, cilantro, radishes
Week 2	Shallots, dill, market turnips, bok choy, head romaine, beets, kale
Week 3	Rhubarb, tatsoi, garlic scapes, radishes, carrots, butterhead lettuce, chard
Week 4	Carrots, Napa cabbage, market turnips, chard or kale, shallots, head lettuce, garlic scapes
Week 5	Fennel, carrots, kale, market turnips, green onions, zucchini, head lettuce, cilantro
Week 6	Peas, garlic, beets, zucchini, broccoli, kale, green onions
Week 7	Broccoli, zucchini, peas, head lettuce, chard, parsley, carrots
Week 8	Napa cabbage, head romaine, green onions, kale, zucchini, carrots, beets
Week 9	Bulb onions, potatoes, basil, chard, zucchini, carrots, head lettuce
Week 10	Salad mix, green onions, kale or chard, carrots, culinary sage, cucumbers, fennel. If you want: zucchini!

Week 11	Padrón peppers, carrots, eggplant, zucchini, kale, fennel, butterhead lettuce, bulb onions
Week 12	Green onions, cucumbers, padrón peppers, kale, head lettuce, beets, zucchini
Week 13	Beans, kohlrabi, head romaine, radishes, basil, eggplant, curly kale
Week 14	Broccoli, beans, zucchini, carrots, cucumbers, tomatoes, green onions
Week 15	Eggplant, tomatoes, head lettuce, sweet peppers, radishes, curly kale, cucumbers
Week 16	Arugula, picnic peppers, head lettuce, tomatoes, beets, carrots
Week 17	Butterhead lettuce, curly kale, fennel, sweet peppers, cilantro, beets, parsnips
Week 18	Lacinato kale, head romaine, leeks, carrots, market turnips, sweet peppers, culinary sage

Here are some helpful tips from Mahonia Gardens:

- The night before you receive your next CSA, go through your fridge and pull out all unused vegetables. Compost moldy items or slimy greens (if you don't have a compost, start one or bring it to the farm when you pick up your food). Make a meal out of all the old veggies. One idea is a frittata, a custard filled with vegetables. Grate or chop roots; sauté first with unsalted butter, diced onions and salt. Chop the greens and add to the pan after roots are cooked, but don't overcook the greens; just wilt them. Turn the stove off. Spoon the mixture into a greased baking pan (8x8) and add six beaten eggs and any spices you love. Add cheese if you like—goat cheese or cheddar. Bake at 350 degrees for about thirty minutes or until the top is lofty and browned and a knife inserted comes out clean. Serve warm. Then you have breakfast for a few days!
- When you receive your CSA, process the food immediately so it does not get lost in your refrigerator. Unpack your bag/box and see what you have. Cut greens off the roots, rinse the greens and bag them. Add greens to soups or make salads.

Chop the roots and put them into glass jars or clear containers so you can see what you have. Consider baking all the roots and you can use them throughout the week in different ways such as on salads, reheated and served over rice or mashed to accompany a protein. Think about each food as you put it into the refrigerator and get excited about it as an individual, as the next cell being created in your body, as each element within it that makes up your being.

• Make sure you store each item properly in a sealed container or a plastic bag so it will last longer.

GROCERY STORES

Bend's population is over ninety-one thousand, and it boasts fourteen different grocery stores. It's not unusual to stop by several stores during a weekly shopping trip, as each store carries specialty items. In 2015, Newport Avenue Market became the first employee-owned store in Central Oregon. It first opened as an Independent Grocers Alliance (IGA) in 1975 and then changed to Newport Avenue Market in 1992. Conveniently located on the westside, the popular store is within walking or biking distance of many neighborhoods. It carries many products made, grown or processed in Central Oregon. Many conventional grocery stores carry local items, so look closely at signage as you walk up and down the aisles. Every time I enter the produce section, I notice more signs listing the farm name and location. Ask the produce employees questions about their suppliers. I recently picked up a butternut squash from Fred Meyer that came from a farm just outside Portland. Market of Choice, the newest store in Bend, supports over three thousand Oregon farmers, food producers and ranchers by carrying their products.

Consider buying seasonally and enjoy produce during peak season. Here are a couple of ideas:

• Don't buy pale, tasteless tomatoes in the winter. Choose a freshly grown root vegetable instead. Jackson's Corner restaurant serves a BLB (Bacon, Lettuce, Beet) sandwich when local ripe tomatoes are not in season.

- Savor fresh, ripe tomatoes when they're in season and pull out those tomato tart and pan bagnat recipes highlighting their flavor.
- Enjoy sweet Oregon strawberries when they're available at the farmers' market. Whip up heavy cream and enjoy them over a shortcake, or eat the entire pint on the way home!

AGRICULTURAL CONNECTIONS

With one call to Agricultural Connections (AC), a busy chef can order fresh produce and sustainably raised meat from several local or regional farms. Otherwise, it would take many calls and time spent calling each farm to inquire about produce, quantities, prices and delivery. Individuals can order desired quantities or purchase a box full of freshly harvested produce at peak season from the same farms —no membership or commitment required. Pickup is at Central Oregon Locavore, making it easy and convenient.

Started in 2010, AC supplies farm-fresh food to restaurants, food carts, grocery stores, companies and individuals. "We're a hub for restaurants and farmers. Restaurants are getting farm-fresh food, and we're hopefully saving them time," says Liz Weigand, co-owner. In the spring of 2017, Manya Williams joined the business as co-owner and business partner. Their warehouse is located in an industrial park in Bend. Two commercial walk-in coolers and a chest freezer fill most of the room. Rolling racks loaded with produce are pushed around the efficient and tidy work tables arranged for packing orders. A small team of dedicated employees helps them distribute farm-fresh food all over Central Oregon.

AC purchases directly from more than a dozen farms in Central Oregon and the Willamette Valley. Farmers submit available harvest items every week, and Weigand lists the items on the AC website. She also e-mails the list to wholesale accounts. Orders are placed via phone or online. Farmers harvest produce in the morning and deliver packed boxes to AC on Tuesday.

A sign reminds staff of the best practices in the warehouse. *Photo by Emil Teague.*

On Wednesday morning, AC employees pack orders that are either delivered or picked up in the afternoon. Food is distributed within forty-eight hours of harvest. In addition to fresh vegetables and meat, AC offers fruit, dairy, eggs, grains, baked goods, granola, coffee, gelato and jam. Year-round vegetables are broccoli, table carrots, celery, onions, cabbage, beets and more.

In the cooler months, winter squash and sunchokes are available, while early spring brings a bevy of mustard greens. Strawberries, sweet potatoes, cauliflower and tomatoes are only available during limited times throughout the year. "We were only able to get strawberries twice this season because of the long winter," says Weigand. She encourages people to try salad turnips, a root vegetable many people overlook. They are small, white and round with a mild flavor. She recommends roasting them, eaten raw as a snack or sliced in a salad.

Approximately 90 percent of their business is wholesale to restaurants and 10 percent to individuals. Each year, their wholesale business grows 30 to 50 percent. Weigand shares, "I love connecting with people, farmers and chefs. Going out and visiting with them—that's the fun part. We're in it together, and we care about each other. Finding chefs at restaurants like Jackson's Corner or 123 Ramen who care about it gives you a cool in-

Staff pack orders every Wednesday. *Photo by Emil Teague.*

sync feeling. It's very rewarding." In addition to wholesale distribution of farm-fresh food, Weigand connects farmers and restaurants by negotiating pre-season contracts between them. A farmer will commit to growing a particular crop and quantity for a restaurant. This helps the farmer in planning for the season, and chefs can count on fresh produce for their menu. She is excited to negotiate more contracts for the upcoming season. "I want to see more chefs buy local food, and I want to see it grow," Weigand expresses. She notes that local demand exceeds supply, which should encourage additional growth.

Weigand has deep roots in the agricultural community. She grew up on a russet potato farm in Central Oregon. Her family has farmed in Madras and Powell Butte since the late 1800s, and her brother is a fifth-generation farmer. "I understand the climate and lifestyle, even though the type of farming we did is very different. I automatically have love and adoration for our farmers," Weigand says.

We talk about the cost of conventional produce versus paying more for locally grown food. She says education and awareness-building help when talking about the value and quality people get for the higher price. "It's impossible to think we'll ever compete on price with big conventional

growers....We would have to be producing on mass scales," she explains. Weigand also points out Americans spend approximately 9 percent of their income on food, whereas Europeans spend 15 to 20 percent on food. "There needs to be a big shift in consumers' and chefs' minds on where food should be priced. Until then, it prevents more local food from being sold," she says. Weigand is optimistic as conversations continue between farmers and chefs. She hopes to see the current foodscape evolve to meet the needs through contracts and new farms entering the marketplace, like Boundless Farmstead.

CENTRAL OREGON LOCAVORE

Megan French and I enjoy our second breakfasts of the day, sitting outside on the patio at Jackson's Corner. It's the perfect place to have a conversation about local food since Jackson's Corner is a leader in farm-to-table. "The reason I'm so attracted to the local food movement is because it encompasses everything important to me—healthy eating, community, economics and sustainability. We're breaking bread together," says French, a board member for Central Oregon Locavore. An acquaintance introduced her to Central Oregon Locavore, and she volunteered at the marketplace. She worked up to manager and then became program director. Now she's on the board of directors and volunteers for several local nonprofits. French is the perfect spokesperson to talk about Central Oregon Locavore's place in the community.

Central Oregon Locavore, a nonprofit organization, was established in 2009 by Niki Timm, a Bend native. She wanted to support the local food movement and began a food co-op that evolved over time into Central Oregon Locavore. It operates a year-round marketplace, offers a variety of programs and events and rents space for community events and gatherings. In May 2016, it moved to a new location with better parking and visibility and also seized the opportunity to reorganize the store. Every fall, they hold a membership drive, with different donor levels receiving marketplace discounts and other perks. The market sells a variety of local produce, meats, poultry, eggs, honey and pantry items along with locally made bath and body products. Each week, the staff candles approximately 1,500 eggs, checking

for impurities and confirming freshness. Cashiers become educators when assisting customers who have questions about products. Most of the cashiers have toured the farms or become acquainted with the producers. One of the biggest concerns from customers is animal treatment and welfare. Central Oregon Locavore purchases from small-scale, sustainable farms that are socially responsible. "We want to educate people in any way possible. Eating local is not a fad to us," says French. "It's also about your relationship with the media. Don't believe the first thing you read, but do some research. Is it sustainable? Are they using safe practices?"

There are fewer conversations about price these days because customers understand and know more about the costs of sustainable farming and soil management. Many are also aware of farms in Central Oregon that follow the same guidelines as organic farms but choose not to be certified for a variety of reasons. Central Oregon Locavore is transparent about the small markup on items, which covers the building lease, utilities and salaries of the employees.

Farm Kids! is a popular program that will easily triple in numbers once additional funding is secured. The program works with teachers to educate school-aged children about where food comes from through field trips to local farms and classroom presentations. In 2017, over seven hundred children in

Refrigerators full of meat, poultry and fish line the wall. *Photo by Emil Teague.*

Central Oregon Locavore's marketplace. *Photo by Emil Teague.*

kindergarten through second grade took part in Farm Kids! Five community volunteers accompany the children on each three-hour field trip. There were fourteen field trips during the school year, and they would love to expand the program to include third through fifth graders. Other programs include Willing Workers On Local Farms (WWOLF), which recruits volunteers for projects on farms; Locavore Food School; and Edible Adventure Crew. Small Farm Support offers tax and finance classes for farmers and other helpful resources.

French's personal favorite event is Fill Your Pantry, a community bulk-buying pop-up farmers' market, where consumers fill their pantries and freezers with beets, winter squash, garlic, honey, fall stone fruits, nuts, cheeses and more. It gives farmers an opportunity to move product inventory accumulated in their greenhouses or barns, making room for the next season. In 2016, the first event was held at the Pleasant Ridge Community Hall in Redmond, and farmers sold $12,000 of produce packaged in ten- and twenty-pound bags in just three hours! In 2017, they added pre-ordering from vendors as an option, plus invited more farmers to participate, along with local restaurants and food carts to sell food at the event. Seven other events held throughout the year keep Central Oregon Locavore busy and provide

opportunities to meet local farmers, shop at the spring pop-up market and enjoy community suppers. The Holiday Gift Faire held in December grows each year, with vendors offering food, art and local crafts.

The marketplace is open six days a week and offers numerous volunteer opportunities and events throughout the year. As eating and buying local continues to build, Central Oregon Locavore is at the forefront, connecting community members with farmers and producers. The board and staff work hard to strengthen and engage the local farm-to-table movement through education and advocacy.

PART IV

DINING OUT

Eating is an agricultural act.
—Wendell Berry

FARM-TO-TABLE MOVEMENT

This movement was begun in the 1960s by early pioneers Alice Waters of Chez Panisse and Jerry Traunfeld of The HerbFarm. They valued quality over convenience and advocated using forward-flavor food. Waters studied abroad in France and returned home, hoping to re-create the simple and flavorful dishes she enjoyed there. She began shopping at farmers' markets and building relationships with the vendors, looking for a diverse selection of vegetables and fruits. She was soon surrounded by a community of farmers who shared the same passion for local and sustainable food. Waters advocates that delicious food is grown with care, harvested at peak season and then delivered directly to the consumer. Start with good soil and passionate farmers, and end with the best-tasting food. Her restaurant, Chez Panisse, highlights ripe and flavorful produce on its menu.

In her book *The Art of Simple Food*, Waters states that she believes good food only comes from good ingredients. Most importantly, she says the price of food includes protecting natural resources and paying fair wages to the people who produce it. I consider this when I buy local food at the farmers' market or dine at a restaurant. When I interviewed Dan Butters from Dump

City Dumplings, he mentioned paying one dollar extra for a local ingredient. He said it was worth supporting local farmers and the community. Sure, he could buy all of his produce from Costco or Cash & Carry, but he makes a conscious choice to source locally, to make an impact not only on the community but also globally.

At the turn of the twentieth century, most of the food eaten came from within fifty miles. But as people moved away from rural areas to cities, they began relying on processed food for ease. Now, there are numerous companies that deliver meals directly to your doorstep—no shopping or meal planning on your part. The meals come packaged with the pre-measured ingredients, along with the step-by-step recipe. I'm not advocating for them or against them—merely pointing out the changes in our lifestyles and the companies catering to us.

It all comes down to this: good cooking starts with good shopping. Take time to select the freshest ingredients, and they shine almost on their own. Taste wins every time.

INGRID ROHRER

Executive Chef at Broken Top Bottle Shop & Ale Café

Ingrid Rohrer grew up in Santa Barbara, California, and has fond memories of plentiful fig trees, apricots and almonds grown in the warm climate. "There's nothing like a fresh apricot," Rohrer recalls. After graduating from California Culinary Academy (now Le Cordon Bleu) in 1992, she worked for ten years as executive chef at Bon Appétit and learned about the strict guidelines regarding organic produce and meat. "You take those values to a local level and practice what you're preaching. It really put it into perspective on a purchasing level, and you see the huge impact," she says. Working for Earthbound Farm furthered her education about sustainability and using organic produce, since it was one of only three certified organic kitchens at the time. It was the first company to launch and sell pre-washed salad mix to stores and other retail outlets. She is still enthusiastic and passionate after thirty years in the restaurant industry. Rohrer smiles when she talks about her different jobs and experiences.

Rohrer joined Broken Top Bottle Shop & Ale Café (BTBS) as executive chef in 2015, and she infuses her style into every menu item. "My food is high-end comfort food of all different ethnicities. The clientele has been very receptive. Our menu caters to everyone and all categories of food," she explains. Her fondness for all types of ethnic food shows up in menu items like the Cauliflower Shawarma Sandwich and Sesame Sushi Salad.

Unlike most kitchens, BTBS does not have any gas appliances. Instead of gas ovens and the typical six- or eight-burner gas stovetop, it has induction

Executive chef Ingrid Rohrer at Broken Top Bottle Shop & Ale Café. *Photo by Emil Teague.*

burners, flattop grills and Turbochef ovens. A Traeger grill sits outside on the patio. "I'm clever about what I can and can't do," Rohrer tells me. Every Sunday, she creates a slate of weekly specials using locally sourced ingredients. A daily special last summer featured grits, Cajun cream gravy, local porcini mushrooms and fresh arugula. It's perfectly cooked comfort food with Rohrer's vegetarian twist on the classic shrimp and grits dish. In the winter, she uses turnips, rutabaga, parsnips, turnip greens and beet greens. Summer brings an assortment of leafy greens, horseradish and heirloom tomatoes.

The menu at BTBS offers a variety of items divided into sections for carnivores, herbivores and piscivores, along with the usual sections like appetizers, salads and entrées. The house-smoked meats are popular, and the chicken wings are a favorite among diners. A twelve-door cooler contains over four hundred beverages to quench your thirst. Wild Chinook salmon from the Columbia River, BigEd's Artisan Bread and Bontà Gelato are a few local items listed on the menu. "People want to know and understand what they're eating. They're stoked to find out their burger came from DD Ranch. They can taste the difference too," says Rohrer. "The locavore trend is already happening, and it's getting stronger and stronger. With all the pop-

up restaurants doing farm-to-table, I think we'll see more outdoor dining. It's fun to do and see."

Every Wednesday, Agricultural Connections delivers a large box of produce from local farms to Rohrer. "It's very exciting because I never know what's in it. I use the ingredients in Thirsty Taco Thursdays," she says. Past ingredients include DD Ranch pork shoulder, garlic scapes, escarole, baby turnips, turmeric and celery root—not your typical taco fillings. She skillfully takes these disparate ingredients and creates delicious and unique tacos.

We shift our conversation to foods Rohrer likes to cook and enjoy when she's not at BTBS. She appreciates nose-to-tail cuisine and eating food prepared in nontraditional ways. Nose to tail involves cooking the entire animal, including the underrated cuts most people would discard. Chefs make luscious broths and dishes using all of the animal, which reduces food waste and challenges their creativity. Meat cheeks and tongue are her selections for tasty items often overlooked.

Rohrer hopes items like bacon, turkey eggs and larger amounts of tri-tip are more accessible in the future. The local food movement continues to grow, and chefs work closely with farmers. She's hugely supportive of them and their dedication. She concludes, "Eating locally is all about community. These are the people supporting whatever business you're in. It stimulates the economy, and you get to know the people growing your food. I know how passionate they are."

DAVID TOUVELL

Executive Chef and Owner at CHOW

Executive chef David Touvell exudes enthusiasm and positive energy as we sit on the patio of CHOW restaurant during the lunch rush on a sunny September weekday. He's relaxed despite having several exciting projects in the works. His next two restaurants are located off Galveston Avenue. "I meet with the landlord of the new space right after this meeting," he says with a grin. In addition to those projects, he plans to add a wood-fired grill in the corner of the lawn at CHOW and offer a small plates menu in the evenings. A full slate of projects will keep Touvell busy over the next few months.

Touvell's first introduction to the hospitality industry was learning scratch baking when he was nine years old. He enjoyed working in the kitchen and followed the career path, giving him some amazing opportunities. He worked in several Michelin-starred restaurants, seeking jobs on the opening team to increase his knowledge while learning the process. In the last ten years, he has designed and opened thirty restaurants and seven hotels. Some of his favorite projects were in southern Oregon and Portland, Oregon. Touvell recently bought out his business partners, and his current portfolio includes CHOW, Local Slice pizzeria, Good Karma Bakery and Cottonwood Café.

The garden at CHOW thrives every summer with tomatoes, radishes, carrots, beans, chili peppers, mint, herbs, squash, fingerling potatoes, purple potatoes and hops. Produce is harvested daily by the staff for use in menu items and the daily specials. They serve approximately forty thousand meals over the five busiest months from May through September, with tourists as a

Right: Located on the popular west side of Bend, CHOW often has live music during breakfast and lunch. *Photo by Emil Teague.*

Below: Raised garden beds at CHOW. *Photo by Emil Teague.*

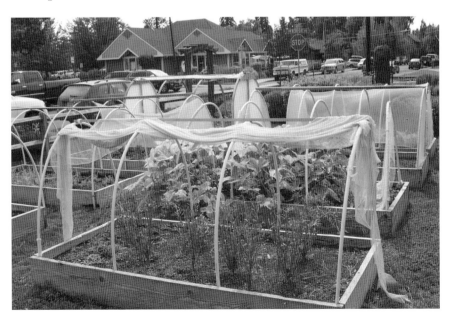

large majority of their clientele. Cooler weather brings back the many loyal local customers, happy to see their favorite servers and enjoy a Bloody Mary. The restaurant seats forty-three guests inside, and a large patio substantially increases its seating in nice weather. Everything is made in-house, including rolls, mayonnaise, hot sauces, four types of bread and more. They use approximately seventy thousand pounds of potatoes a year. We talk about CHOW going through nine hundred eggs a day and the size farm needed to supply that quantity consistently. "There are some good people growing amazing stuff. It's a benefit to the community, but it's hard to sustain because there's not enough supply. I try to support the farmers and always will. But the farms and chefs need to come together and focus. The market dictates what people supply and demand," says Touvell. His statements echo what other chefs and local food advocates have mentioned.

We shift our conversation to cooking for his wife and four children. Many of the meals showcase the flavors of Mediterranean, Arabic or Lebanese food. In the summer, he prepares tomatoes in a variety of ways. Touvell loves wild mushrooms, fiddlehead ferns and hazelnuts—all the iconic Oregon foods. "To me, the Pacific Northwest is amazing whether you're a chef or not," he says.

His wish list for locally sourced items includes more onion varieties, cheeses and meats. CHOW's website lists over twenty-five local farms and vendors it supports. It used to list the local farms on the menu, but Touvell thought it overwhelmed diners. His overall goal is for people to be happy and enjoy the food. Touvell says, "We focus on what goes on that plate, and they enjoy it."

BRIAN KERR

Executive Chef at Deschutes Brewery & Public House

Brian Kerr remembers sitting in the sunny backyard of his grandmother's home in San Jose, California, eating fresh plums, apricots, pluots and apples, juice dripping down his wrists. It is a fond memory on his journey to becoming the executive chef at Deschutes Brewery & Public House. When his mother enrolled in nursing school, he took over cooking duties for the family. At fifteen years old, Kerr mastered simple foods like lasagna and casseroles and then moved onto grilling or pan-sautéeing fresh fish, caught in the West Fork of the Coquille River in southwestern Oregon. As he was living in the country, fresh milk or cream was a staple for daily cooking. He enjoyed the challenge of creating and balancing flavors in dishes. Kerr signed up for a restaurant class at a nearby community college in 1987, launching his career in the culinary industry, and then traveled all over the world. In addition, he trained to become a saucier through the Culinary Institute of America in St. Helena, California.

Deschutes Brewery & Public House opened in 1988 and is a popular destination among locals and tourists, with booming sales during the summer. Nineteen rotating taps of its craft brews, including special or small batches, are a big draw. The menu showcases locally sourced items, including the Juniper Elk Burger or Northwest Fish and Chips, dipped in Mirror Pond Pale Ale batter. At the entrance, a large chalkboard lists many local vendors, including Novicky's Farm and Fields Farm. Kerr has worked at Deschutes Brewery & Public House since 2013 and has noticed a change in people's attitude toward local food. "There's definitely been a

big shift. Now, people want to educate themselves more and know where it's sourced. We try to honor that," he says. The restaurant works directly with farmers and also utilizes Agricultural Connections when searching for particular items. Spent grain from the brewing process is used in several ways on the menu—try the pretzel with a stone-ground mustard, Black Butte Porter and cheese dip! Its beef comes from Barley Beef, a small group of family-run cattle farms in Central Oregon. Spent grain from the brewery operation is trucked out to feed the cattle, with other items going to farms for compost used as soil amendment.

When we talk about food trends, Kerr has a ready answer from his observations and experience. "I think we'll see a stronger push for vegetarian or veganism, but it'll be a flexible attitude. For example, you'll eat meat three days a week and then vegetarian for the remaining," he says. Deschutes Brewery & Public House's latest menu increased vegetarian or vegan selections by 50 percent. Its vegan cashew flatbread has olive oil, grilled artichoke hearts, roasted tomatoes, spinach, cashew parmesan, arugula salad and fresh herbs. Kerr also wants to create more dishes showcasing local colorful beets or eggplant.

During the summer, Kerr invites a line cook to shop with him at the Bend Farmers' Market every Wednesday. They walk from the kitchen, pulling a

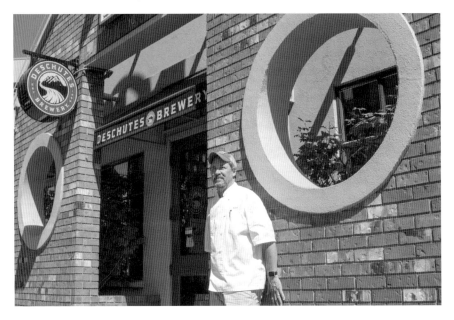

Executive chef Brian Kerr in front of the original public house, opened in 1988. *Photo by Emil Teague.*

A chalkboard at the entrance lists locally sourced food. *Photo by Emil Teague.*

rolling cart, and spend quality time with the vendors. "I love to go down there and visit with the farmers. I load up and wheel the cart back through the restaurant so diners can see farm-fresh food. My favorite seasonal ingredient is asparagus. It's a signal that winter is over. Whether large and thick or dainty and small, it's a great palate to work with. In the fall, I love chanterelle mushrooms. And I recently had fresh spinach so dense, sweet and leafy…it was miles above the packaged stuff," Kerr shares. He advises people to buy fresh produce and cook it at home, tasting the difference. Kerr adds that a store-bought tomato pales in comparison to a fresh homegrown tomato. He urges people not to be afraid of items like romanesco broccoli, a chartreuse-colored vegetable with a spiral appearance. He suggests pickling, roasting or shredding it into rice.

Deschutes Brewery & Public House hosts several beer and food pairings throughout the year. Kerr develops special menus for the dinners, along with participating in community events. He represented the restaurant in the local Top Chef competition, a part of the Bite of Bend festival. "It was my third time, and it was lots of fun. The pantry was stocked well," says Kerr. He competed against seven chefs, showcasing a secret ingredient with one hour to complete a composed dish.

Kerr always has an Asian cookbook and a vegetarian cookbook on his desk. He's a big fan of David Chang and Yotam Ottolenghi. "I love the vibrant colors and the flavors used in those cookbooks. The amount of effort, real work and testing done by chefs like them….They know they're held to high standards. Cooking takes a great deal of passion to do it well. For me as a chef, their work reminds me to work harder and to create the best that ingredient offers." This closing statement reflects Kerr's respectful and modest attitude. His genuine perspective on the hard work from chefs every day to provide delicious seasonal food provides much admiration.

Spring Olson of Central Oregon Seed Exchange. *Courtesy of Abacus Photography.*

Red beets and carrots at the Bend Farmers' Market. *Photo by Emil Teague.*

Left: Red chard is one of forty crops grown at Mahonia Gardens. *Photo by Emil Teague.*

Below: Curing garlic in the shed at Mahonia Gardens. *Photo by Emil Teague.*

Above: Blackened Salmon Tacos topped with chipotle crema, cabbage, cilantro and roasted tomatillo salsa served on corn tortillas at Broken Top Bottle Shop & Ale Café. *Photo by Emil Teague.*

Right: Cherry trees at Fields Farm. *Photo by Emil Teague.*

Crops soak up the sun at Fields Farm, the only farm inside Bend's city limits. *Photo by Emil Teague.*

Arugula and Kale Salad from Sunny Yoga Kitchen has herbs, dates, almonds, mizithra cheese, red onion and apple cider–oregano dressing. *Photo by Emil Teague.*

Sunny Bowl from Sunny Yoga Kitchen has spinach, kale, peppers, onion, coconut curry sauce, garbanzo beans, cilantro, quinoa and jasmine rice with a sunny-side up egg. *Photo by Emil Teague.*

Locally grown baby ginger and turmeric used in several menu items at Sunny Yoga Kitchen. *Photo by Emil Teague.*

Above: Ground cherries at Dome Grown Produce. *Photo by Emil Teague.*

Left: Tomatoes in varying stages of ripeness at Novicky's Farm. *Photo by Emil Teague.*

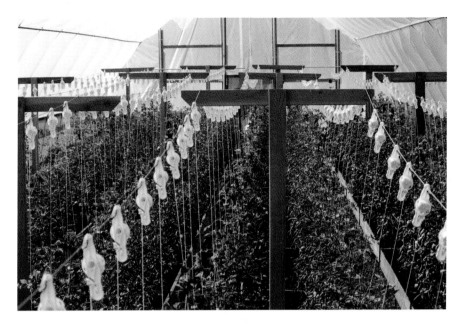

Tomato plants at Novicky's Farm are strung up using RollerPlasts, which helps avoid slipping or jumping from the wire. *Photo by Emil Teague.*

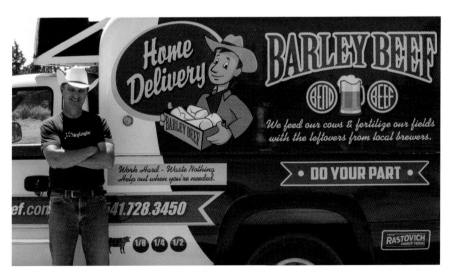

Rob Rastovich, owner of Barley Beef, is also a computer programmer and a yogi in addition to being a cattle rancher. Truly a Renaissance man! *Photo by Emil Teague.*

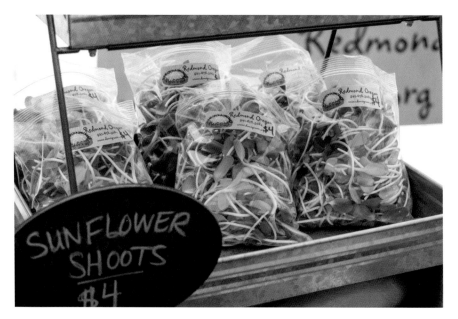

Sunflower shoots for sale from Dome Grown Produce. *Photo by Emil Teague.*

Tasty samples of bread from Jackson's Corner at the Bend Farmers' Market. *Photo by Emil Teague.*

Right: Turmeric plants fill the greenhouse at Tumalo Fish and Vegetable Farm. *Photo by Emil Teague.*

Below: Produce display at Central Oregon Locavore's marketplace. *Photo by Emil Teague.*

French Market uses hazelnut shells as ground cover in its garden. *Photo by Emil Teague.*

Braised pork cheeks, seventy-five-degree egg yolks, spicy harissa and tomato broth at French Market. *Photo by Emil Teague.*

A variety of pickled vegetables at 123 Ramen. *Photo by Emil Teague.*

Ramen bowl with slow-roasted pork, sesame miso kale, slow-poached egg and a side of pickled vegetables from 123 Ramen. *Photo by Emil Teague.*

CHOW reuben sandwich loaded with fourteen-hour beer-braised corned beef, house-made sauerkraut and 1000 island served on Mama's white bread. *Photo by Emil Teague.*

Lillian Hoffman loads up cones with broiler chickens at Great American Egg. *Photo by Emil Teague.*

Right: Espresso vanilla crème brûlée at Broken Top Bottle Shop & Ale Café. *Photo by Emil Teague.*

Below: Dan Butters, co-owner of Dump City Dumplings, preps the cart before opening for business. *Photo by Emil Teague.*

Above: One lone turkey and several chickens in the pasture at Boundless Farmstead. *Photo by Emil Teague.*

Left: Flerd in the pasture at Golden Eagle Organics, Inc. *Photo by Emil Teague.*

Above: Executive chef Brian Kerr of Deschutes Brewery & Public House. *Photo by Emil Teague.*

Right: Colorful bell peppers for sale at the Bend Farmers' Market. *Photo by Emil Teague.*

Above: Baby squash, uni, dungeness crab, squash blossoms, nasturtium flowers and dashi broth at French Market. *Photo by Emil Teague.*

Left: Weekly salad special at Jackson's Corner has local beets, carrots, fennel, beet molasses and chopped pistachios atop whipped ricotta. *Photo by Emil Teague.*

DAN BUTTERS AND KEITH SHAYON

Co-Owners of Dump City Dumplings

Stroll around any festival in Central Oregon and you'll likely see a long line of people waiting for a warm steamed bun dumpling. The line moves quickly as people walk away balancing plates full of Chinese Pork, Pad Thai or Four Cheese Pizza dumplings with hand-crafted sauces. In addition to those three main flavors, they run rotating special dumplings, such as the Mediterranean Lamb, a savory mix of feta, rosemary, garlic and mint. Dump City Dumplings food cart also serves late-night revelers in downtown Bend most weekends. Owners Dan Butters and Keith Shayon began the business in June 2010, when they moved from Ohio and noticed a need for a food cart offering more variety than typical bar food. "Keith and I hosted a bunch of dumpling parties in college, so it was kind of a natural progression once we were in Bend," says Butters. They developed a dumpling menu with popular flavors and accompanying sauces catering to local tastes. Butters handles the food shopping, production and festival side of the business, while Shayon handles payroll and paperwork, plus manages daily duties when Butters is out of town with one of the carts at a festival. At the Oregon Eclipse 2017 at Big Summit Prairie, they sold over twelve thousand dumplings. "It was insane, the craziest ever. We sold every dumpling we made," Butters says.

When Dump City Dumplings opened for business, there were only four other food carts in Bend. Since then, those carts have moved on to traditional restaurant storefronts or gone out of business. Now, Central Oregon has over fifty food carts in fixed or mobile locations. Dump City

Left: A variety of handcrafted sauces accompanies the dumplings. *Photo by Emil Teague.*

Below: Dan Butters, co-owner of Dump City Dumplings, is ready for business at the Bend Roots Revival music festival. *Photo by Emil Teague.*

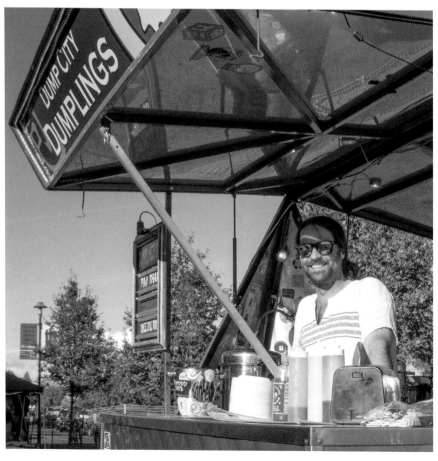

Dumplings stands out by having several carts for different events and offering unique fare using locally sourced ingredients. They have three carts; the smallest one measures four and a half feet by six and a half feet, covered by a large umbrella. The newest and largest cart measures seven feet by twelve feet. All carts are designed by Michael Weeks with Butters's input and assistance. Carts are easily towed by a truck to festivals all over the Pacific Northwest. "We're a unique product and fit into the food scene at most festivals. I also try and get into music festivals where I like the music," Butters confesses with a smile.

Butters doesn't have formal culinary training, but cooking and food have always interested him. At ten years old, he loved spending time in the kitchen making sandwiches. He recalls feeding a sandwich creation to his cousin Andy. It consisted of sliced cheese, lunchmeat, pickled jalapeños, mustard and chili powder, plus a sprinkling of other spices ransacked from the kitchen cabinet. Andy ate the entire sandwich, much to Butters's delight. Since specialty sandwiches are still a passion for Butters, we talk about our favorites in Bend. He recommends several from Planker Sandwiches and Brother Jon's Public House. Butters also has fond memories of eating his grandmother's lasagna and sneaking extra helpings of her flaky croissants.

Butters majored in international studies at Kenyon College, where his thesis focused on local communities making a global impact. When starting the food cart, he researched local food options and began buying from Agricultural Connections. "Our dumplings are good, inexpensive and use locally sourced ingredients. I think people are surprised by that....I try to be humble about it, but that's the way it should be," says Butters. He lists many reasons for buying locally: the products are fresher, readily available and not much more expensive. He does wish there was a domestic producer of soy sauce, a staple ingredient requiring extensive equipment and special handling for consistent flavor. "I keep longing for more local specialty stuff. But it's definitely coming around. Now, I'm buying local raw organic apple cider vinegar," Butters says. His favorite cooking ingredients are lime and vinegar. "It ups the flavor profile so much. I'm also working on my broth game," he shares. Butters believes strongly in the local food movement and supporting the community. He says it's something his employees can be proud of and convey to customers. In addition to buying locally, he teaches dumpling classes at the Bite of Bend festival and at Pepperberries kitchen store in Eugene, Oregon.

Renting the kitchen at Seven Restaurant and Nightclub gives Dump City Dumplings a place for preparation of the dumplings and sauces.

They are looking for a larger kitchen as they increase production. Future goals include a small brick-and-mortar storefront and selling dumplings wholesale. Creating delicious, quality dumplings for customers to enjoy at their convenience is a welcome challenge. Butters also wants to provide year-round employment for his loyal, dedicated employees. When he's not mixing up dough for dumplings or working at the cart, Butters is a ski instructor at Mount Bachelor ski resort during the winter. He loves the mountain culture and coaching his students, watching their progression through the season.

I ask if there's a typical customer who eats at food carts. He says, "Definitely—a more adventurous personality. Plus, it's a good place for a quick bite to eat before going to another event in the community. You connect with the person making your food. You take a bite in front of them. There's this beautiful exchange."

LUKE MASON

Executive Chef at French Market

W elcome to French Market. Everything is farm-to-table. Have you dined here before?" asks the server to a table of three guests who just sat down. "We're a seasonal restaurant, so our menu is always changing depending on what's available from local farms. Let me tell you what's new this week." I'm immediately impressed by the server and his introduction to the table. When I mention it to Luke Mason, executive chef at French Market restaurant, he smiles and says, "We change six to eight items on the menu each week. The servers take notes at our staff tasting every Wednesday." Mason gives them information on each item so they can approach guests confidently. Every Sunday, Mason and his sous-chef sit down with the list of available products from local farmers and brainstorm dishes. "I rely heavily on Liz Weigand at Agricultural Connections, who makes it all possible. I call her my broker. I don't have time to go to the downtown farmers' market. Other than citrus, everything comes from them, and I receive deliveries twice a week," he says. "I don't write an item on the menu unless she has it in stock."

Mason stays in the realm of French techniques in his cooking, although the resulting menu may not be thought of as "classic French." He points out, "French food is regional and pulls from influences all over the world. Diners are hit with flavor, and now we're bringing the visual aspects of the food together. I love fresh ingredients, and I just want to treat them with respect. We take good products, and we don't mess it up." His intention is to cook great local food at a reasonable price point. The owners, Phil

Executive chef Luke Mason in the garden at French Market. *Photo by Emil Teague.*

and Judy Lipton, support his vision and gave complete creative control to Mason after he demonstrated his cooking skills and showcased flavors for Phil's birthday party. They know good food and have traveled all over the world. Judy has many years of experience in the food industry as a restaurant owner and caterer. They chat with diners and give feedback to Mason. "The support has been incredible....The amount of repeat customers. I'm humbled and honored. It's been a wild ride so far, but very fulfilling," Mason says.

French Market is nestled in the midst of the Old Bend neighborhood downtown in an old cultural building that was home to several restaurants previously. During extensive renovations, the owners kept the large glass-sided refrigerators along one wall. They also installed a tall glass refrigerator case inside the entrance to sell specialty French items. Adjacent to the outdoor patio seating is a garden planted by Mason's fiancée just six days before the restaurant opened. Beds were built, six yards of dirt delivered and crops planted. Cracked hazelnut shells from Portland cover the ground, preventing weed growth and providing a unique look. His fiancée maintains the garden, including hand-pollinating the corn. Additional crops include tomatoes, peppers, herbs, beans and Mason's favorite vegetable: squash. He likes squash as a versatile ingredient for sweet or savory preparations.

"Fall is my jam. This season we're about to hit. Cinderella pumpkins and more," shares Mason. He suggests people should try cooking with treviso and radicchio, both leafy vegetables in the chicory family. Mason advises they just need a little love in preparation and cooking since they're often associated with a bitter taste.

Mason grew up in Sandpoint, Idaho, where he enjoyed spending time in his family's large backyard garden. He started in the restaurant industry at thirteen and a half years old as a dishwasher. While majoring in political science and living in Santa Barbara, California, Mason worked in restaurants, spending more and more time in the kitchen. He moved to San Francisco in 2010 and worked at Aziza, a one-Michelin-star restaurant. "My time there definitely made me as a chef. I look at it as graduate school. I met my goals and blew them out of the water," Mason shares.

His introduction to farm-to-table cuisine came from his time working at Wildwood restaurant in Portland, Oregon. Almost all of the food served at Wildwood was grown within a three-hour drive from the city, and it was a farm-to-table mainstay for almost twenty years before it closed. Mason is passionate about supporting local farmers and establishing relationships with them. When he expressed interest in fresh escarole, Gigi Meyer of Windflower Farm grew it for him. For sourcing pea shoots, he turned to

One of the features retained from French Market's renovation is the glass-door refrigerators. *Photo by Emil Teague.*

James Berntson at Radicle Roots Farm. Mason hopes the network here will grow stronger between farmers and chefs. As an example, he talks about the strong and longtime collaboration between farmers and chefs in the San Francisco Bay Area. "Farmers got together with chefs and asked, what can we grow? What can you use at your restaurant?" By selling directly to restaurants instead of going through a wholesale company, farmers received top dollar for their produce. It also helped in crop planning and gave them a steady buyer instead of having to rely solely on moving produce at the farmers' market.

Mason is dedicated to the success of French Market, and his strong work ethic is evident. In addition to cooking and expediting, he often delivers food to tables and engages with guests. As we're talking, he observes the front entrance and the servers taking care of tables while easily answering my questions. We talk about the next dining trends, and Mason mentions forage-centric models, where guests can bring their own game or produce. But he returns to farm-to-table cuisine and explains, "We're headed to restaurants who are cooking right from the source, like Cory at Wildwood restaurant in Portland was doing in the '90s. The trend of two-hundred-seat restaurants is going away. People care about where their food is coming from, and the state of our planet is waking people up." At the end of the interview, I ask if there's anything else he wants to share. He concludes, "Dining here isn't a transactional thing. I want people to know we care about them. Food is my life, and it takes that kind of dedication to be good. My hope, as a community of chefs, is that we push each other to do better. We need to work harder and do the best job we can."

Note: At press time for *Bend Food*, Phil and Judy Lipton closed French Market.

PARKER VAUGHAN

Executive Chef at Jackson's Corner

As a young child, Parker Vaughan watched Julia Child and Jacques Pépin cooking shows on public television while other children watched cartoons. He was raised in Half Moon Bay, California, and a favorite food memory is picking wild olallieberries and making jam with his mother. His family always had a large garden, and he fondly recalls canning and pickling produce in the kitchen. Vaughan's father was a hobby botanist, and their yard contained over 120 varieties of succulents and a dozen palm trees.

Vaughan's first introduction to the hospitality industry was working at a Mayan restaurant when he was a teenager. He remembers Mayan, Spanish and English being spoken by the staff. Vaughan worked front of the house and in the kitchen. Cooking had always interested him and became a clear career path as he gained experience over the next several years. He moved to Bend in 2007 and was on the opening crew of Jackson's Corner at its westside location. After a successful opening, Vaughan moved to San Francisco and worked for Mission Street Food, which was known for its pop-up restaurant, catering and spirits events. He describes the work as basically building a restaurant from scratch, almost weekly, and collaborating with chefs from different restaurants. He returned to Bend in 2015.

THE RESTAURANTS

It's a lovely September fall day as Vaughan and I sit at the westside location during a rare downtime. The cozy restaurant is closed for five days for annual maintenance. As we talk, people knock on the door and peer in the windows despite the signs announcing the closure and notification on social media well in advance. Jackson's Corner stays busy year-round, with locals meeting friends for breakfast or lunch, conducting business meetings over coffee or bringing their families for pasta and pizza in the evenings. "Fall for us is very transitional. One crazy to a different kind of crazy," Vaughan says. As executive chef, his time is split between the bakery, westside and eastside locations.

Jackson's Corner is located in a historic brick building that once housed Delaware Grocery. It was built in 1924, with an icehouse added in 1936, but burned down in the 2000s. Once rebuilt, the grocery opened as Jackson's Corner, an open-market concept with grocery aisles and an array of prepared foods made in-house. It also had a bakery, coffee bar and pizza oven. As people began requesting breakfast and other items, the menu and format evolved organically. Now it's a farm-to-table-driven restaurant.

Opened in November 2014, the eastside location is conveniently located near medical campuses, housing developments and shopping centers. An open design provides plenty of light, and the self-service beverage cooler is replicated from the westside location. A separate coffee counter offers speedy and convenient ordering for walk-in traffic. Plenty of parking and patio seating make this location a popular place on the east side of town. Trivia theme nights, live music and lawn games provide steady dinner traffic and entertainment.

"We're definitely labeled as farm-to-table. It's hard to communicate to people the length we go to in sourcing locally. And it's difficult to communicate that through our counter service. We try our best," Vaughan says. Each week, Jackson's Corner offers eight specials, all using local or regional ingredients. A recent small plate special has beets from Rainshadow Organics, Hood River pears, whipped blue cheese, pecan brittle and watercress. Vaughan holds a staff tasting every Thursday, where he talks about the ingredients and dish preparation. When tomatoes are no longer in season, a golden beet is substituted on the popular Bacon, Lettuce and Tomato sandwich. Kitchen staff dubs the beet the "winter tomato" and uses it in salads and weekly specials. Vaughan also invites local farmers to meet staff and present information about their farms. On a recent visit from Imperial Stock Ranch,

Executive chef Parker Vaughan of Jackson's Corner hand stretches pizza dough, which keeps the crust airy. *Photo by Emil Teague.*

The blackboard at Jackson's Corner lists the specials of the week. *Photo by Emil Teague.*

they learned about raising livestock, sustainability practices and the process of shearing wool.

Contracts with local farmers aid in a steady supply of fresh produce. "We're trying to push every ingredient as a local product, not just putting local radishes on a salad made with ingredients bought elsewhere," Vaughan says. He would like to see more people using local flour from Rainshadow Organics or embracing storage crops like alliums, squash and root vegetables. "Because of the High Desert and the Cascade Mountains, the true growing season is May to October. It's figuring out how we can extend that year-round with crops that can be stored or dried," Vaughan adds. We talk about the relationship between farmers and chefs. He mentions that groups in San Francisco and Sonoma County have been working together since the seventies. Farms in California specialize in crops grown specifically for restaurants whereas it seems many farms here grow the top five popular items everyone wants. "I have a good time here working with farmers to produce items I want. However, the farms here are small and are trying to produce for the market. There's potential for more commercial growth," Vaughan advises.

As he was growing up in California, citrus was a big part of Vaughan's life, and he misses the abundance of options. He wishes it could be sourced locally but understands the climate here is not necessarily conducive to citrus. We talk about different vegetables that grow well here in the High Desert, and he mentions celery as his favorite. "It's one of those vegetables people take for granted. It can be pickled, grilled, eaten raw, used for stock or sauces. The versatility is amazing. It can be sweet, salty, crisp or juicy. The leaves act as an herb, so it's a great replacement for parsley," Vaughan says. He really enjoys cooking with wood, either grilling or smoking. A meal of grilled vegetables with lemon, olive oil and salt is satisfying. We shift our conversation to food trends, and Vaughan says it's already happening— simplicity. Highlight two or three ingredients in a simple dish and produce it extremely well. Cookbooks including *On Vegetables* by Jeremy Fox and *Six Seasons: A New Way with Vegetables* by Joshua McFadden capture his attention right now.

Jackson's Corner employs over eighty people, and the restaurants continue to gain momentum. Vaughan's approach toward local food and supporting farmers is refreshing and welcoming. He is thoughtful, engaged and honest about the current foodscape and how it must evolve to support the demand for fresh local food.

THE BAKERY

In June 2016, Jackson's Corner opened a bakery behind the restaurant's westside location that focuses on bread and rolls. It was a two-hundred-square-foot yoga studio and now holds mixers, ovens and worktables. The staff of six people bake three thousand pieces a week, providing all the bread for both restaurants, delivered each day. During the summer, they also sell approximately three hundred loaves each week at the Bend Farmers' Market.

Harrison Scheib and Evan Miller are hard at work while we talk one early morning. Scheib scatters flour on wooden boards and preps for the next batch of loaves. Using a digital scale, Miller measures flour and water for bread dough destined for the floor mixer. Handwritten notes about baking times and water temperatures are written on subway tiles above a worktable. Scheib says, "My first baking memory is making frosted cut-out cookies with my grandma at Christmas." Scheib's first job was as a bread delivery driver, and that's when he realized his fondness for bread. Prior to his job at Jackson's Corner, he spent four years baking at Fire Island Rustic Bakeshop in Anchorage, Alaska.

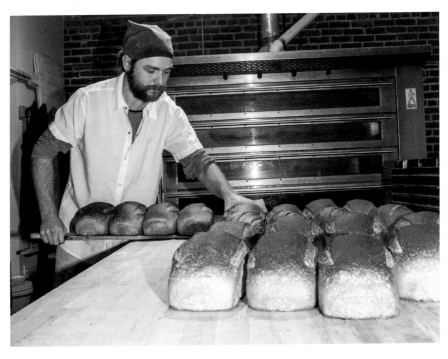

Harrison Scheib removes the house bread from the oven. *Photo by Emil Teague.*



Evan Miller mixes up dough, weighing each ingredient carefully on a scale. *Photo by Emil Teague.*

The baguettes are the most popular item and are made with 100 percent organic flour from Central Milling Company, based in Logan, Utah. The flour company buys directly from farmers who practice sustainable growing methods. Jackson's Corner also uses Camas Country Mill flour, which is grown and milled in Junction City, Oregon. Each week, the bakers experiment with different flours and add-ins. A recent loaf had dried blueberries, hemp seeds and einkorn flour, the world's most ancient wheat. A happy surprise was making slabs, a free-form bread. It had a nice shape and open crumb and can be cross-utilized for different menu items. They refined the process for the slab bread, and now it's baked daily along with their house bread, baguettes, country loaf and others.

Baking bread is a lengthy process, but the reward of a warm slice from the oven with a knob of butter is worth it. The house bread uses a sourdough starter, which is fed every day with flour and water to remain active and healthy. Bread dough is mixed and sits out at room temperature for two and a half hours. Next, it's shaped and placed in pans and then moved to the refrigerator to rise overnight. Finally, it's baked the next morning. "That moment when you see it come out of the oven. It's risen the way we want it to, and you cut into it when it's cool," says Scheib. "It's definitely a joyous moment."

The art of baking bread may seem daunting to some people. Active yeast, kneading and proofing are all important steps in baking. Using a digital scale, measuring the temperature of flour and liquids and adjusting as needed give the bakers much success. Plus, lots of practice! "Baking is all about the numbers. Things can change even based on the temperature in the room," Scheib says. Miller agrees and adds, "There are lots of variables like temperature and humidity fluctuations. It's always changing."

The bakery launched its assortment of artisanal breads at the Bend Farmers' Market this past season. It offered samples with the option of dipping them in olive oil. Currently, the bakery provides breads for Lone Pine Coffee Roasters, Bos Taurus, Thump Coffee and Sip Wine Bar. In October 2017, Jackson's Corner launched a bread-share program, where customers order online by Sunday night and pick up bread on Wednesday afternoon. Bread classes are slated to start this winter. "We really like our bread, want other people to enjoy it and get our name out. People come here for breakfast but not necessarily for bread," says Scheib. They want to eventually open a self-standing bakery and continue pushing the bread movement here in Central Oregon. "I love being able to share my passion about baking. It's for the community we care about. We made that bread and that experience for them," Miller expresses happily.

MOVING FORWARD

Jackson's Corner and the bakery are at the forefront of the farm-to-table movement in Central Oregon. They fully embrace the community of farmers and spend time working with them to supply produce and sustainably raised meat for the diners to enjoy. For Vaughan, it's hard work and an emotional investment, while very rewarding. His quiet passion is inspiring and leaves an indelible impression.

ANNA WITHAM

Chef and Owner at 123 Ramen

There's a rhythm always happening in the kitchen. You're working with other people, and you keep egos out. It's all about grace and communication; same with dancing," says Anna Witham, owner and chef of 123 Ramen restaurant. We talk about how her loves of cooking and dancing are connected. For five years, she's been dancing with Fe Fanyi, a local troupe incorporating drum and dance from West Africa. Performing at the 2016 Technology, Entertainment and Design (TEDx) event in Bend was an unforgettable experience for Witham.

She opened 123 Ramen in the Bend Makers District in February 2017 and says her love for making pickles drove the menu featuring ramen bowls, steamed buns, kimchi, cold sesame noodles, sandwiches and more. Summer Sunday brunches include seasonal items such as sourdough waffles with peaches and cream or biscuits and lamb chorizo gravy. Approximately 90 percent of her ingredients are locally sourced. The organic ramen noodles are made in Portland, Oregon, by Umi Organics, using wheat grown in the Pacific Northwest. "It feels so good to be putting this local food out there in the world. I love supporting the farmers. They work so hard to make good things grow. I'm so happy," Witham grins as she talks about all the love put into each menu item. Her latest creation, Ra-ta-ta, is a ramen noodle frittata topped with kimchi aioli.

Her introduction to ramen was from a lovely man who cooked with her approximately four years ago. They made ramen and geeked out over flavors, vegetables and meat preparation. "It was one of those rare conversations

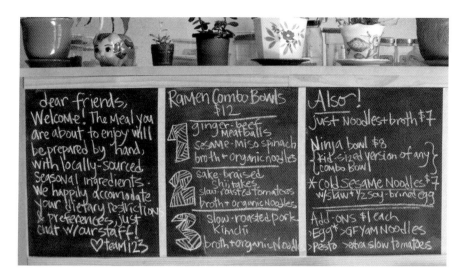

A chalkboard lists the menu, and the vegetables showcased in the bowls change depending on the season. *Photo by Emil Teague.*

that never stopped," Witham says with a smile. Much of her cooking education is hands-on, connecting with people she admires, reading books and experiencing food in the world. "I've spent the last four years catering, doing pop-up events and challenging myself to try new things," she says.

One of her earliest childhood food memories is squeezing fresh lemons and adding sugar to a pitcher in her play kitchen. She also has fond memories of making pancakes and hash browns with her dad at church breakfasts put on by her youth group. Witham adds it was so beautiful watching him teach the art of flipping pancakes to the group.

Her latest pop-up dining event was a collaboration among poetry, music and food at Bend Art Center called Creative Feast. Witham developed a menu based on the exhibit and her connection to the art. A musician then carried on the theme through music. She looks forward to more pop-up dining events like Creative Feast, Last Saturday at the Workhouse and collaborations with farmers, like the Fall Harvest Dinner with Seed to Table Farm.

"I love the ephemeral nature of pop-up events. The people there get to share that experience. I can take risks, and there's a beauty and deliciousness coming out of those risks," says Witham. She lists the challenges of pop-up dining as using a kitchen not designed to serve food, creating a menu based on space restrictions and hauling food and supplies. It was a big learning

Anna Witham, chef and owner of 123 Ramen. *Photo by Emil Teague.*

curve, but Witham enjoys challenges. Pop-up dining events are more popular in larger cities, but Witham is introducing them to people here in Central Oregon. The reception has been tremendous.

Since Witham is such a huge proponent of using locally sourced ingredients, I ask if there are any items she's unable to source. She doesn't hesitate in answering. "Duck. I love duck. It was on the menu when I first opened, but I couldn't source it locally. Everything else is sourced locally, so I took it off the menu because it just didn't seem right," she states. Her favorite seasonal ingredients are radishes and cucumbers—perfect for pickling and showcasing flavors like ground sesame seeds, miso and rice vinegar. "I love teaching staff about pickles and seeing what they come up with. A recent creation is thinly sliced celery root with preserved lemon and Thai chilies," she shares.

Ground cherries are her pick for an underrated item people should buy from the farmers' market. It's like a gooseberry crossed with a cherry tomato, all wrapped up like a tomatillo. Rainshadow Organics sells them, along with a variety of produce, at the Bend Farmers' Market. Her eleven-year-old son loves eating their ground cherries and spreads the gospel, encouraging people to buy them. Taco night is a favorite meal cooked at home by Witham, and she says there are no fights between her two sons when serving epic tacos. Her older son is an adventurous eater, and his favorite school lunch is sushi, while her younger son enjoys bagels and cream cheese.

The industrial neighborhood location for 123 Ramen works well. "I feel so lucky to be here. Some customers say it's hard to find, but you get the people who really want to be here and eat. That's who I want to feed. There's a nice quietness in this neighborhood," says Witham. For her, 123 Ramen is really about weaving community together. "Connecting with farmers, dining together and giving loving, compassionate service. My overall goal is feeding people nourishing food."

COURTNEY AND AMY WRIGHT

Owners of Sunny Yoga Kitchen

L ook, the wall doesn't even go to the ceiling," says Courtney Wright, co-owner of Sunny Yoga Kitchen. She points to a wall separating the 114-square-foot kitchen from their yoga studio. She and her wife, Amy, opened Sunny Yoga Kitchen on Valentine's Day 2014 in the heart of the NorthWest Crossing neighborhood center. It's a unique shared space offering yoga classes; a kitchen serving a full menu, including beer and wine; and a space for community events. The yoga studio has small tables hinged to the walls that fold down for dining. Stacks of chairs next to cubbies full of neatly folded blankets in the back of the studio are easily pulled out at lunchtime. Colorful artwork adorns the walls. It feels light and airy, thanks to the 26-foot ceilings and industrial design.

Once the space was approved for Sunny Yoga Kitchen, the Wrights launched a Kickstarter campaign in December 2013, complete with an architectural drawing so supporters could visualize the space. "It really helped with the last little push, and it was a professional way to do it. Some of the items we offered were ten yoga classes and a juice as one of the levels for donating. Local people bought that before we even moved in! It helped introduce us to the community. We also offered swag items such as aprons and hats," says Courtney. About 50 percent of their business is from yoga classes, and a majority of the attendees often enjoy a meal or juice after class. Sometimes, first-time customers stopping in for a quick lunch are not aware of the slate of yoga classes available. They return for a class and become loyal fans of Sunny Yoga Kitchen.

Courtney Wright puts away chairs at the end of a busy lunch. *Photo by Emil Teague.*

With a background in kinesiology, Courtney teaches Vinyasa yoga and also gracefully handles front-of-the-house duties in the restaurant, taking orders at the small counter or delivering food to customers. Amy takes care of back-of-the-house and has twenty-six years of experience in the culinary industry, previously working at Zuni in San Francisco and Imperial restaurant in Portland, Oregon. "I'm like the ninja chef…very quiet if I'm prepping while a yoga class is happening," Amy laughs. The menu features healthy organic food, including a variety of salads, sandwiches and bowls. Everything is made in-house, and they have daily specials such as crepes on Saturdays. The Golden Juice has turmeric, baby ginger, carrot and orange served over ice. It's vibrant and full of flavor. Amy says they taste each batch to maintain consistency and adjust as needed. The turmeric and baby ginger are sourced locally from Tumalo Fish and Vegetable Farm. Their most popular dish is the Sunny Bowl, piled high with spinach, kale, peppers, onions, coconut curry sauce, garbanzo beans, cilantro, quinoa and jasmine rice. A sunny-side up egg is a great add-on to the bowl. For a sweet ending to a meal, Sunny Yoga Kitchen offers chocolate avocado mousse. "People try it, and they're crazy about it. They end up taking three of them home," Courtney says.

In the summer, vendors from the NorthWest Crossing Farmers' Market stop by Sunny Yoga Kitchen offering produce. Kale is especially welcome

since it's used in many menu items. The Wrights talk about how local farmers are growing everything sustainably and without the use of pesticides or herbicides. They suggest people talk to farmers and ask about growing practices instead of only looking for an organic label, which many small farms do not obtain. The Wrights share how easy it is to support the local farmers by purchasing from Agricultural Connections. One call to them, and Sunny Yoga Kitchen can buy from several farms in the area without having to call each farm and inquire about available produce and quantities. Amy also adds that Fields Farm is five blocks from their home, and she can stop in there for cilantro or other produce as needed. "People feel comfortable in asking where our food comes from....I think it's because we're so personal," says Courtney.

The counter service at Sunny Yoga Kitchen is different than at other casual dining restaurants. Staff deliver food and continually check on guests, asking open-ended questions. They clear away dishes and reset tables for the next round of diners. Staff take a sincere interest in the dining experience from beginning to end. "Courtney and I are both lifers in this business. We use cloth napkins, quality flatware and BPA-free glasses. You'll notice we don't have a bus tub or a trash can sitting out in the dining room. We

Courtney and Amy Wright, owners of Sunny Yoga Kitchen. *Photo by Emil Teague.*

developed a more personal approach to counter service, and we want to talk to our guests," Amy says.

It's definitely an adjustment from their time in California, where the sunny climate provided consistent business and fresh produce year-round. Snow and cold temperatures here in Central Oregon present myriad challenges in the winter. Sometimes, orders can't get delivered because of icy roads, kale freezes on a farm or parking is difficult due to large amounts of snow piled up. It impacts the attendance in yoga classes, along with the menu and daily offerings, so flexibility is key in the kitchen. The snowy weather is good for the Wrights, who both enjoy snowboarding, but it can adversely affect business. Summertime is busy because of their convenient location nestled in the neighborhood center. During the farmers' market season, additional staff work on Saturdays due to increased business, and patio seating fills quickly. With three schools located nearby, they're consistently busy in the spring and fall with teachers, parents and students stopping by for a nourishing meal or juice. "We love being in this neighborhood. We've already expanded once and extended the kitchen four feet. We would love to have a second location on the eastside. It's needed in your repertoire," Courtney says with a smile.

COOK LIKE A LOCAL

Fried Green Tomatoes
Courtesy of Novicky's Farm

Medium to large green tomatoes from Novicky's Farm
½ cup cornmeal
½ teaspoon salt
1 large egg
2 tablespoons butter
2 tablespoons canola or other mild-flavored oil
1 tablespoon chopped basil and/or parsley (optional)
Salt and pepper

Slice, but don't peel (the skin holds them together), the tomatoes about ½ to ¾ inch thick. Take very thin slices from the top and bottom and discard or reserve for another use.

Mix the cornmeal and salt together on a plate. In a small bowl, thoroughly beat the egg.

Melt butter and oil together over medium-high heat. Dip a slice of tomato into the egg, let excess egg drip back into the bowl and dip quickly into the cornmeal on each side and put immediately into the hot pan. Repeat until the skillet is full but not crowded. Fry until lightly browned, turn and fry the other side. Remove to a warmed plate and fry remaining batches.

Serve warm, adding salt and pepper to taste. Sprinkle with the chopped herbs, if using (if you wish, the herbs can be added to the beaten egg).

Escabeche-Style Beet Pickle
Courtesy of Anna Witham, 123 Ramen

Halve beets and then slice ¼ inch thick until you have 4 to 5 cups worth. Thinly slice half an onion. Heat ¼ cup neutral oil (avocado oil recommended) in a 2-quart saucepan. Add onions. Stir and fry until fragrant and softened. Add sliced beets, 2 to 3 dried chili peppers, 1 tablespoon oregano and 2 teaspoons salt. Fry for 5 minutes, stirring frequently. Then add apple cider vinegar and water in equal parts (start with 1½ cups each), enough to cover the veggies. Simmer and cook until beets are cooked to your desired tenderness. Remove from heat and cool. Stores indefinitely in the refrigerator.

Smoked Cedar Holiday Turkey Brine
Courtesy of Spring Olson, Central Oregon Seed Exchange and Sakari Botanicals

2 gallons water
4 tablespoons fresh local garlic, chopped
1½ cups smoked cedar salt (Sakari Botanicals)
½ tablespoon ground black pepper
⅓ cup coconut sugar
¼ cup Worcestershire or soy-based sauce
5- to 10-pound local turkey, depending on the size of your attendance

Choose a large food-grade container that will fit the whole turkey and water/brine mixture. Mix together the water, garlic, smoked cedar salt, pepper, coconut sugar and Worcestershire or sauce of choice in the container. Add the turkey. Store in the refrigerator for up to 2 days before preparation.

Note: This recipe will yield a large amount of smoked meat great for sandwiches, holiday dinners, soups, stock, casseroles, etc. If you are able, try to choose a local farm to purchase your turkey and other vegetables and seasonings from, and it will increase the value and flavor of this unique traditional northwestern recipe.

———————

Pickled Turmeric

Courtesy of Bob Camel, Tumalo Fish and Vegetable Farm

1 pound baby turmeric
3 ounces onion
1 tablespoon sea salt
4 ounces apple cider vinegar
2 ounces honey or sugar
4 ounces fresh-squeezed lemon juice
1 ounce mustard seed

Slice turmeric and onion very thin. A mandoline slicer is best to achieve consistency.

Put in a bowl and mix in the salt. Let sit for 30 minutes. Pack in a sterile mason jar.

Bring vinegar to boil in a small saucepan, then add the honey or sugar, lemon juice and mustard seed. Immediately pour into mason jars. Let cool, then refrigerate.

Note: It can be enjoyed in 3 weeks if you can wait. Excellent on sandwiches, burgers, steaks or salads.

———————

Pickled Ginger

Courtesy of Bob Camel, Tumalo Fish and Vegetable Farm, from The Kitchn.com

12 ounces fresh ginger
1 large red radish (optional)
1 ½ tablespoons kosher salt
½ cup rice vinegar

1 cup water
1 ½ tablespoons granulated sugar (optional)

Equipment:
Chef's knife or mandoline
Small spoon for peeling
Cutting board
1 wide-mouth pint jar with lid
Measuring cups and spoons
Canning funnel (optional)

1. <u>Prepare the jar:</u> Wash the jar and lid with warm soapy water, rinse well and dry before using.
2. <u>Prepare the vegetables:</u> Peel the ginger using a small spoon. Thinly slice on a mandoline or with a knife. Thinly slice the radish, if using.
3. <u>Salt the ginger:</u> Combine the ginger and salt in a small bowl. Set aside for 30 minutes.
4. <u>Fill the jar:</u> Put the radish, if using, into the jar. Add the ginger and pack tightly.
5. <u>Make the pickling brine:</u> Combine the vinegar, water and sugar in a small saucepan over high heat and bring to a boil, stirring to dissolve the sugar. Pour the brine over the ginger, filling the jar to within ½ inch of the top. You might not use all the brine.
6. <u>Remove air bubbles:</u> Gently tap the jar against the counter a few times to remove all the air bubbles. Top off with more pickling brine if necessary.
7. <u>Seal the jar:</u> Seal the jar tightly.
8. <u>Cool and refrigerate:</u> Let the jar cool to room temperature. Store the pickles in the refrigerator. The pickles will improve with flavor as they age; try to wait at least 48 hours before cracking them open.

Note: These pickles are not canned. They can be stored in the refrigerator for up to 2 months. If you process and can the jars, they can be stored at room temperature unopened.

———————

Barramundi with Lemon Butter Sauce
Courtesy of Bob Camel, Tumalo Fish and Vegetable Farm

3 barramundi fillets
2 teaspoons canola oil
Salt and pepper to taste
1 clove garlic, minced
2 tablespoons butter
3 tablespoons fresh lemon juice
Small bunch of fresh basil (can also use ¾ teaspoon dried basil)

Coat the barramundi with canola oil, season with salt and pepper and place in a heated nonstick skillet over medium-high heat. Cook for about 4 to 5 minutes on each side, until the fillets are lightly browned. Move to a serving dish and keep warm while you make the sauce.

In the same pan, reduce the heat and gently cook the garlic in the butter for about 2 minutes. Stir in the lemon juice and fresh basil.

Spoon the sauce over the fish and serve immediately.

Note: I would suggest cooking the sauce first and setting it aside, then cook the fish. If you are not a fan of fish normally, be sure to give this one a try. It may change your mind!

Kale Salad
Courtesy of Amanda Benkert, Dome Grown Produce

Bunch of dinosaur kale, chopped
Fresh lemon juice
Pinch of salt
½ cup dried or fresh fruit of your choice (like blueberries)
½ cup nuts (pecans, pine nuts or pistachios)
4 to 5 chopped scallions
2 cups cooked quinoa
Asian sesame dressing
Bragg Liquid Aminos or soy sauce
Grated parmesan for topping
Chopped avocado for topping

Chop kale and put into a bowl with some lemon juice and a pinch of salt. Bruise/smash with wooden spoon until kale is soft. Add fruit, nuts, scallions and quinoa and mix.

Add Asian sesame dressing to your liking and a splash of Bragg or soy sauce. Top with grated parmesan and avocado.

Grateful Bowl
Courtesy of Amy and Courtney Wright, Sunny Yoga Kitchen
Makes 4 servings

2 cups julienned cabbage
¼ cup julienned carrots
1 cup julienned Italian kale
6 mint leaves
Salt and pepper to taste
**Garnish ¼ of an avocado for each bowl and a squeeze of lime*
4 cups cooked brown rice
2 cups cubed and roasted sweet potatoes
2 cups cubed tempeh

Ginger Vinaigrette Dressing
3-inch piece of fresh ginger, peeled
¼ cup olive oil
2 tablespoons rice wine vinegar
2 tablespoons honey
½ teaspoon ground coriander
½ orange, squeezed
Salt and pepper to taste

Blend the dressing ingredients in a blender or food processor. Toss cabbage, carrots, kale and mint with salt and pepper to taste. Combine with the vinaigrette and set aside. Slice your avocado into quarters and set aside. Sauté rice, sweet potatoes and tempeh with salt and pepper to taste until soft and browned slightly. Distribute rice mixture into four bowls and add kale

mixture onto rice mixture, then garnish with avocado and a squeeze of lime, salt and pepper.

Radish and Cilantro Relish

Courtesy of Mahonia Gardens

2 cups radishes, thinly sliced
½ cup onion, chopped (you could use green onions from our CSA)
3 tablespoons orange juice (freshly squeezed)
2 tablespoons lime juice
2 tablespoons (or more) fresh cilantro, chopped
2 tablespoons olive oil
Salt and pepper to taste

Mix ingredients. Refrigerate/marinate for at least 1 hour before serving.

Creamy Fennel Pesto Sauce

Courtesy of Mahonia Gardens

Fennel fronds
Olive oil
Nuts (pine nuts, almonds, walnuts)
Cheese (parmesan, hard cheddar)
Something spicy (jalapeños, pepper flakes)
Heavy whipping cream
Salt and pepper to taste

In a food processor (or good blender), blend fennel greens (fronds) with olive oil (or your preferred oil such as coconut). This is the base of your pesto, but you can add any array of things to make it your favorite (use what's in your fridge!), such as other greens, basil, garlic or scapes, green onion tops, parsley or cilantro. Blend with nuts, cheese and something spicy.

Put the mixture into a small pot and heat on low, stirring and cooking the greens for flavor.

After a few minutes, add heavy whipping cream to your taste/ consistency. Continue stirring on low as the sauce thickens (you can substitute coconut cream or any non-dairy options).

Lastly, add salt and pepper to taste.

Note: This sauce is great over pasta. You can chop up the fennel bulb and sauté it in butter and sage as a pasta topping.

―――――――――

Carrot Soup with Tangled Kale
Courtesy of Mahonia Gardens, adapted from the magical Deborah Madison

1 onion, thinly sliced
1 ¼ pounds carrots, thinly sliced
1 bunch (or less) fresh garlic scapes, chopped
1 heaping tablespoon fresh peeled ginger, slivered
1 teaspoon ground cumin
Butter, ghee or coconut oil
4 cups water or stock
1 bunch of kale
Salt
Squeeze of lime juice

Sauté onion, carrots, garlic scapes, ginger and cumin with butter, ghee or coconut oil for 5 to 10 minutes.

Add 4 cups water or stock and bring to boil. Simmer until veggies are soft, about 20 minutes.

While the soup is cooking, prepare the kale separately. Remove the stalks. Roll the kale leaves lengthwise, then slice thinly crosswise. Sauté greens in a bit of water until wilted, about 2 minutes.

Drain excess water and toss hot kale with coconut oil, salt to taste and a squeeze of lime juice. Set aside.

When soup is ready, purée until smooth (in blender or with immersion blender).

Make it how you like it! If too thick, add a little water. If too bland, add salt and pepper. Return to the pot and warm it back up.

Ladle soup into bowls and set a tangle of kale atop each serving. Enjoy!

Celery Root and Carrots
Courtesy of Karen O'Donnell

1 large celery root
6 to 7 carrots
½ cup (or less) heavy cream
¼ cup (or less) dry sherry

For the celery root, peel, trim off ends and brown spots and cut into ½-inch chunks. Cut the carrots in ½-inch chunks (no need to peel). Place diced celery root and carrots in a large pot and cover with salted water. Bring to a boil, reduce heat to medium-low and simmer until just tender, 20 to 30 minutes Drain the cooked celery root and carrots and return to the warm pot (heat turned off). Hand mash until creamy and slightly chunky (you do not want them completely mashed). Gradually add cream and sherry and adjust taste to your liking. Serve warm.

Pork Ragu with Greens and Rigatoni
Courtesy of Brian Kerr, Deschutes Brewery & Public House

Extra virgin olive oil
3 pounds pork butt, cut into fist-sized chunks, seasoned liberally with salt and pepper
1 large onion, diced small
2 tablespoons garlic, minced
1 cup roasted red bell peppers, either homemade or canned (drained)
3 tablespoons tomato paste
6 fluid ounces Deschutes Brewery Obsidian Stout
1 28-ounce can whole peeled tomatoes in juice
1 sprig thyme
1 sprig rosemary
Water to thin
Salt to taste
Pepper to taste
¼ cup balsamic vinegar

Rigatoni
1 tablespoon garlic, minced
Greens: chard, baby kale, spinach or arugula
Pecorino romano or parmesan cheese for garnish
Aleppo peppers or crushed red peppers for garnish

Heat a large, heavy-bottomed pan, add 3 tablespoons of light olive oil or neutral salad oil and add the well-seasoned pork pieces. Brown them on all sides over medium heat; this will take some time, so be patient. Don't turn the heat up high or you will risk burning the meat and the fond. Once the pork has browned and gained a crust, remove the pan from the heat. Remove the pork and set aside on a sheet pan or a platter to rest. Pour off all but 2 tablespoons of the remaining oil and wipe away any burnt parts on the pan, leaving behind all the good brown stuff (fond).

Add the onion and return the pan to medium heat, stirring the onion until it softens and browns gently. Add the garlic and cook for another minute. Add the peppers and the tomato paste and cook, allowing the tomato paste to caramelize lightly, stirring frequently. Deglaze the pan with the stout beer and scrape all the yummy browned bits off the bottom of the pan, incorporating them into the sauce. Cook gently until almost all of the liquid is gone.

Crush the tomatoes in juice by hand into small bits and add to the pot. Stir it all together and add the pork and all accumulated juices to the pot. Add the herbs and tuck them into the sauce. Bring to a gentle boil. Reduce the heat to a simmer and lay a piece of parchment on top of the simmering sauce so that only a small portion of the sauce is visible; this will slow the reduction down as the sauce simmers.

Simmer the sauce and meat for 3 hours, keeping an eye on it for the last hour. When the meat is tender and will break apart easily, pour everything out into a large rimmed baking sheet, Pyrex baker or other shallow rimmed vessel. Allow to cool.

Break up the meat with forks or by hand, shredding into bite-sized pieces. When ready to serve, put the ragu into a pot; the ragu will be thick at this point, which is where the olive oil and water will come in. Use them equally to thin and season the sauce, using more or less of either one to suit your taste. Taste and season with salt and pepper and tablespoons of balsamic vinegar until you get the desired level of sweet, savory and tartness.

Boil some rigatoni in salted water according to package directions or your own instinct. Drain, reserving a few tablespoons of cooking water, which you can add to the sauce for body and flavor.

Heat 1 tablespoon of oil in a hot pan, add 1 teaspoon minced garlic and a big handful of baby braising greens like chard, baby kale, spinach or arugula. Toss to soften the greens, add the pasta and the sauce and toss well to combine. Serve garnished with pecorino romano cheese or parmesan and some aleppo peppers or crushed red peppers.

Note: This is also servable family-style for passing around the table.

Spaghetti Squash Lasagna
Courtesy of Ingrid Rohrer, Broken Top Bottle Shop & Ale Café

8 spaghetti squash

Cut off stem and cut squash in half lengthwise. Scoop out seeds and discard. Rub the squash with olive oil and season with salt and pepper. Place cut side down on sheet pan and fill pan with water. Roast at 400 degrees for about 1 hour until tender (when you poke with fork, it gives way). Let cool and scoop out contents into bowl. Drain off any extra water.

Mix with
2 cups asiago cheese, shredded
Salt and pepper

Ricotta mix
Sauté 1 bag of spinach with olive oil, 2 tablespoons of garlic, salt and pepper. Let cool, then squeeze dry and mix with:
24 ounces ricotta cheese
½ cup asiago cheese, shredded
1 bunch basil, chiffonade
1 tablespoon salt
1 teaspoon pepper
1 tablespoon garlic

Tomato basil cream sauce
3 yellow onions, rough chop
4 tablespoons garlic
1 tablespoon dried oregano
2 #10 cans diced tomatoes in juice
3 cups cream
12 ounces tomato paste
1 bunch basil
Salt and pepper to taste
¼ cup sugar

Directions for sauce
Sweat onions, garlic and oregano. Then add tomatoes, cream and tomato paste. Simmer for 30 to 40 minutes, add basil and purée. Season with salt, pepper and sugar.

Assembly
This makes three half hotel (two-inch) pans. In each half pan, put ½ cup tomato basil cream sauce, then a layer of spaghetti squash, top with mozzarella cheese, then ricotta filling, then another layer of squash, then tomato basil cream, then mozzarella. Top each serving with a basil leaf. Each half pan yields 9 servings. Cover with plastic wrap, then foil and bake at 350 for 1½ hours. Remove plastic and foil and brown the top for 10 minutes. Blot any extra moisture if needed.

Sweet Chili Garlic Sauce
Courtesy of Dan Butters, Dump City Dumplings

½ red bell pepper
¼ bunch cilantro, stems included
2 ounces fresh garlic
2 ounces fresh ginger, peeled
½ cup sugar
1½ cups water
¾ cup apple cider vinegar
2 teaspoons salt
1 tablespoon potato starch or cornstarch mixed with 1 tablespoon water

Cut bell pepper, cilantro, garlic and ginger into dime-sized chunks. Add to the food processor with a splash of vinegar and grind into a smooth, uniform paste. Add paste to a saucepan with sugar, water, vinegar and salt. Using a medium flame, heat mixture until bubbling gently. Whisk in starch mixture and continue to heat until starch has cooked in. Remove from heat, cool and enjoy on everything.

———————

New Potatoes

Courtesy of Jess Weiland, High Desert Food & Farm Alliance
Central Oregon boasts an abundance of root crops that grow so well in our well-draining (almost too well-draining) volcanic soils. While the noble Kennebec and striking Viking Purple potatoes are staples throughout the winter months, I think there is no finer treat than tender tubers when they first come out of the ground in late July. I love this way to eat potatoes because it is straightforward and special—just like our High Desert home!

Olive oil (enough to coat the potatoes and pan)
Salt and pepper to taste
1 ½ to 2 pounds of new potatoes (either halved or quartered—whatever you have to do to make the potato pieces the same size)
A few generous tablespoons of butter (herbed butter if you are feeling fancy)

Preheat your oven to 400 degrees. Heat up a cast-iron pan on your stovetop slowly until you get to a medium-high heat. Cover the surface of the pan with a healthy amount of olive oil and a sprinkle of salt and pepper. Arrange potatoes cut side down in a single layer on the skillet (you may have to do this in batches). Cook the potatoes (resist moving them around the pan too much) until nice and brown, 6 to 8 minutes. Then put the whole pan in the oven to finish baking until fork-tender, another 15 minutes or so. Melt butter on top and add more salt and pepper to taste.

———————

Sous Vide Leg of Lamb with Black Olives

Courtesy of Brian Lepore, Golden Eagle Organics, Inc., adapted from
Seriouseats.com

6 ounces (about 1 cup) pitted Kalamata olives
1 medium garlic clove, minced
1 ounce (about 1 cup) fresh parsley
3 tablespoons extra virgin olive oil, divided
½ butterflied boneless leg of lamb (4 to 5 pounds)
Kosher salt and freshly ground black pepper

Combine olives, garlic, parsley and 2 tablespoons olive oil in the bowl of a food processor. Process until a chunky paste forms, scraping down sides with a rubber spatula as necessary, about 20 seconds. Transfer mixture to a bowl.

Spread half of mixture evenly over inside of lamb leg, then carefully roll it back up.

Secure lamb leg with butcher's twine at 1- to 1½-inch intervals, starting from both ends and working toward the center. Season exterior generously with salt and pepper.

Preheat a sous vide water bath to desired temperature according to the chart below. Seal lamb inside a vacuum bag or a zipper-lock bag using the water displacement method, then submerge and cook for desired time according to the chart below.

When ready to serve, remove lamb from bag and carefully pat dry with paper towels. In a cast-iron, carbon steel or nonstick skillet, heat remaining 1 tablespoon olive oil over high heat until lightly smoking, then add lamb and cook, turning occasionally, until well browned on all sides, about 4 minutes total.

Remove twine, slice lamb and serve immediately with remaining olive mixture.

Note: Brian likes to use Trader Joe's Olive Tapenade instead of making his own. Very flavorful!

SOUS VIDE BONELESS LEG OF LAMB TEMPERATURES AND TIMING

Doneness	Temperature Range	Timing Range
Very rare to rare	115°F (46°C)–124°F (51°C)	2 to 3 hours
Medium-rare	125°F (52°C)–134°F (57°C)	2 to 6 hours (3 hours max if under 130°F/54°C)
Medium	135°F (57°C)–144°F (62°C)	2 to 6 hours
Medium-well	145°F (63°C)–154°F (67°C)	2 to 6 hours
Well-done	155°F (68°C) and up	2 to 6 hours

ENGAGEMENT AND ADVOCACY

Consider other ways to support the local food community through volunteer opportunities, engagement and sharing your experiences with local food. Meet dedicated people and learn about their incredible efforts in creating access to fresh food.

Here are a few ideas:

- Volunteer for a work project on a farm.
- Sign up for a Meet Your Farmer dinner at a local restaurant. Enjoy delicious food and listen to a presentation by the farmer.
- Attend a class held at Central Oregon Locavore. Topics range from beekeeping to seed saving.
- Enjoy locally sourced foods and talk about your experience with friends and family.
- Volunteer to accompany children on a farm tour and watch their faces as they taste a freshly harvested carrot.
- Share your talented cooking skills with others through Cooking Matters, a program by High Desert Food & Farm Alliance.
- If you have a garden, save seeds and donate them to Central Oregon Seed Exchange or plant them again next season.

Through my research for this book, I met and talked with some amazing people. They truly lead by example in their commitment to nourishing and strengthening our community.

CENTRAL OREGON
SEED EXCHANGE

My most joyous moment is giving a packet of seeds to every kid at an elementary school. It's an opportunity to give all demographics a way to grow something of their own. It's free....There's no stress involved. And hopefully they get outside more," says Spring Olson, founder of Central Oregon Seed Exchange (COSE). In 2017, Olson provided free seed to five schools (Montessori and elementary) in Central Oregon. Either the school or Olson secures donations of dirt, soil amendment and gardening tools. Olson supplies the seed and then teaches students and staff how to plant their garden. All of the seed is organic, local and not genetically modified (non-GMO), plus she selects crops that will grow easily. Cold-climate crops include root vegetables, lettuces, cilantro, basil, peas, beans, broccoli, cauliflower and cabbage. Then, it's up to staff and students to maintain and harvest the garden throughout the season. More schools want gardens, so collecting and saving seed is in high demand. Olson also participates in Women, Infants and Children (WIC) annual events in La Pine, Redmond and Bend. She provides seeds for cilantro, squash, peas and carrots, plus includes gardening instructions and recipe cards for parents. Oregon State University sets up a soil station, making it simple for parents to plant the containers right there and take them home.

With a background in the science industry, Olson serves on several advisory boards and teaches classes locally and nationally on seed saving, plus provides consulting to new farmers on a variety of topics. She started

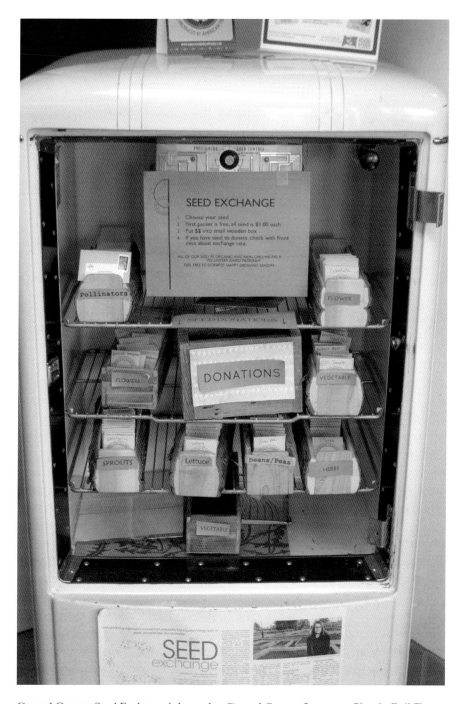

Central Oregon Seed Exchange is housed at Central Oregon Locavore. *Photo by Emil Teague.*

COSE in 2012 when a friend gave her a bunch of seeds one spring day. She knew many local farmers through her consulting work and was acutely aware of the lack of options to buy local seed. A business license bought that evening and a marketing plan twenty minutes later launched the business. COSE now provides seed annually to five to eight thousand people. Olson handwrites every label attached to the seed packets. The COSE logo features a Sitka spruce logo, a nod to Olson's Alaskan heritage. The goal of COSE is to create a sustainable local food supply and support regional biodiversity. Olson works to increase local seed saving, increase seed exchange, provide education on seed saving and support sustainable agriculture.

A grant from Chugach Alaskan Corporation provided construction of a new eight- by ten-foot shed. Seed collection occurs May through November. During spring and summer, the shed is used for drying and processing. After the first snowfall, Olson cleans the seeds and tests for germination. Displayed in a vintage refrigerator, seeds are available for sale February through June at Central Oregon Locavore. Farmers and the general public may purchase seeds or drop off seed donations. Both vegetable and flower seeds are available, along with a Deschutes Pollinator Mix designed to increase habitat enhancement. The mix includes a variety of native and nonnative annual and perennial wildflowers, which attracts bees, butterflies, moths and other insects. Olson mentions climate and time as some of the farming challenges here in Central Oregon. "Too much heat can damage seed…or a hailstorm. If the flower is damaged, then the seed is damaged," Olson explains. She mentions that some farmers don't have time during the season to save seed or don't want to let go of their seed because of proprietary reasons, which she understands.

To increase seed saving and exchange, three local farms donate space in their greenhouses or fields for seed production. Olson also has one-eighth of an acre at her home where she planted organic purple garlic, a new crop this year. The garlic will be infused in a salt for Sakari Botanicals, another company Olson owns. She will save the seeds from the garlic and donate them to COSE; thus, the entire plant is used. She also grows several crops specifically for tribal groups, saves the seeds and gives them back to the tribes. The American Indian Foods Program endorses both COSE and Sakari Botanicals.

COSE will continue to grow, with new drop-off locations in Redmond and Sisters, once additional funding is secured. Olson wants to make it easy for farmers and individuals to buy and donate local seed. She

expresses, "I want people to learn to grow their own food. And I want to reduce obesity rates, provide education…engage parents and children. Everyone's grandmother had a big garden. It's about getting back to the old days of doing something together." Olson's passion for collecting seed and protecting varieties will provide the next generation with high-quality and good-yield produce.

HIGH DESERT FOOD & FARM ALLIANCE

The High Desert Food & Farm Alliance (HDFFA) organization offers several programs and events supporting consumers, producers and the community. Its mission is to support a healthy and thriving food and farm network in Central Oregon through education, collaboration and inclusivity. Jess Weiland, food and farm director, has experience and firsthand knowledge of farming from working on a three-acre CSA farm in Wisconsin. "Working in a food system nonprofit is similar to other facets from my time on the farm. There's endless need and work to do, but you know your limits. You celebrate every victory, no matter the size," Weiland says. She adds that working at HDFFA, building community around food, is her dream job.

PROGRAMS

Combining the education and sustainability core values, one of the most popular programs at HDFFA is Cooking Matters, which empowers families with limited budgets and skills to learn healthy cooking at home. The classes are taught by home cooks, professional chefs and nutritionists, all volunteering their time and expertise. Participants learn meal preparation,

food budgeting, grocery shopping tips and nutrition one evening a week for six weeks. The free classes are offered at multiple locations, and food is provided, along with recipe books. One of the participants shares, "I learned to cook things differently. It was huge when my son actually said he liked the vegetables I cooked for him. It was great to prepare healthy food in a way that will actually get eaten by my kids. I'm glad I can introduce more veggies into my kids' diet."

"Cooking Matters is one of my favorite programs. It also doesn't have to be complicated. For example, start simple and talk about different ways to eat more vegetables," Weiland says. Deschutes, Crook and Jefferson Counties rank high in food insecurity and low in access to fresh food. The U.S. Department of Agriculture defines food insecurity as the limited or uncertain availability of nutritionally adequate or safe foods or limited or uncertain ability to acquire foods in socially acceptable ways. HDFFA works to increase access to fresh, healthy food in a way that supports the local food economy and connects with those populations that are underserved. HDFFA recently partnered with clinicians and programs like WIC to increase healthcare referrals to nutrition education classes. Weiland says, "It's exciting to connect local food with localized healthcare and community wellness." Since the program began in 2014, volunteers have taught fourteen classes, with 508 total participants. The program continues to grow, with classes already scheduled ahead.

Another program is Seed to Supper, where beginner gardeners on a limited budget learn to grow food for their families. Space to grow using container gardening supplies or a community plot is provided, along with learning about planting, choosing vegetables for our climate, soil management, harvesting and seed collection. HDFFA also partners with the Central Oregon Intergovernmental Council (COIC) and the Central Oregon Health Council (COHC) to identify nutrition wellness programs, their impact and how the programs can be improved or accessed by more residents. The overall goal is to better understand how people access nutrition wellness programs and find out ways to more effectively serve people interested in improving their health and well-being or those experiencing food insecurity or diet-modifiable diseases.

HDFFA has a booth every week at the NorthWest Crossing Farmers' Market and Bend Farmers' Market. The table has seed packets, information cards and Food & Farm Directories piled high. In May, HDFFA publishes a directory listing farmers, restaurants using locally sourced ingredients, specialty food businesses and additional resources for consumers. The

Families harvest produce from the garden. *Courtesy of High Desert Food & Farm Alliance.*

most recent directory includes helpful articles such as deciphering food labels, benefits to buying locally grown food and a seasonal harvest chart. Producing the guide provides an opportunity for Weiland to check in with current partners and reach out to new businesses. She notes this area is quite entrepreneurial, and there are many new small food businesses. We talk

about comments she hears at the farmers' market. Weiland says, "People ask if we can grow tomatoes in the High Desert. I think people are still discovering we have an abundance of food here and potential for more. We're seeing more greenhouses. People are pushing the boundaries of the growing season." She's happy to share growing success stories with people stopping by the booth.

Through the Grow and Give program, HDFFA collects fresh produce donations at farmers' markets from customers, farmers and backyard gardeners to supplement nonperishable goods for families. The donations are then distributed by the NeighborImpact Regional Food Bank. HDFFA also collects food from farmers through gleaning, a process of gathering leftover produce from the fields with the help of volunteers. In 2017, Casad Family Farms donated over 11,500 pounds.

EVENTS

Funded by a grant from the U.S. Department of Agriculture (USDA), the Local Food Challenge connects participants with the food community through a variety of activities for one week. Each day, HDFFA sends out an e-mail with trivia questions, articles about food or farm-related topics and challenges like buying a new-to-you vegetable at the farmers' market or thanking a restaurant that uses locally sourced ingredients. Daily drawings for prizes, with a grand prize of a cooking class and a basket full of food goodies, keep participants engaged. Local companies like Sakari Botanicals, Hope Springs Dairy, Holm Made Toffee and others offer special discounts during the challenge. Over ninety people signed up for the 2017 Local Food Challenge, an increase over last year. "I was impressed with the turnout and engagement of the community. Because of the new interactive format this year, the level of engagement increased. In the past two years, people would participate one or two days, but this year, most people took part the entire week," shares Weiland. The first year was a photo submission contest, and the challenge has grown each year, with weekly events and increased opportunities to engage with local farmers and producers.

I participated in the Local Food Challenge and looked forward to daily e-mails from HDFFA. Each activity was different, and it challenged me to be creative and more adventurous in my eating and cooking. Because of the challenge, I tried celery root for the first time; made African Peanut

Soup, a new recipe that included fresh collard greens from Fields Farm; and learned about growth times for popular vegetables grown here. That information will come in handy when I select vegetables to plant in my garden next year.

Another event is the Crooked River Open Pastures (CROP), featuring tours, farmers' markets and family-friendly activities hosted by farms or community members located in Crook County and supported by HDFFA. In 2017, eight different locations hosted events, and participants experienced activities such as making soap, spinning wool and wandering through a lavender labyrinth. Visitors receive a passport and collect a stamp for each event they attend, entering them into a contest to win a basket filled with items from each farm.

In November, HDFFA hosts an autumn social for community members, partners, farmers, volunteers and sponsors. It's an opportunity to mingle and celebrate local food and the farm community. Throughout the year, HDFFA supports a group of local chefs where they socialize, share resources, discuss barriers and celebrate successes. HDFFA also supports farmers and ranchers, offering workshops, resources and opportunities for grants and additional funding.

ENGAGEMENT

Weiland and I talk about the increased interest in locally sourced food. "I think knowing where it's sourced is becoming increasingly expected now by the residents of Central Oregon and the tourists. Our region has that 'High Desert pride' and recognizes the value of food grown close to home.…In terms of local foods' positive impact on our local economy, community wellness and preserving the open landscapes make our region special," she says. Our conversation shifts to additional ways to support farmers and the community. Weiland expresses, "Talk about local food and your personal interaction with it. Share your experiences with friends and family. That makes a huge impact. Voice your support of regional agriculture to representatives. For example, funding for a farm-to-school program was on the chopping block. People called and wrote letters. The funding was restructured, but it stayed in the budget. Lastly, vote with your dollar.…Keep communities healthy and sustainable by supporting the people growing our nourishment. Consider the ripple

effect when you buy a quarter of a cow from a farm here. The money stays here and goes to pay the local labor, buy local feed, preserve our working landscapes and more."

Goals for HDFFA include expanding its cooking classes and inviting more local farmers and restaurants into the conversation. The organization also works to increase access to local food in a way that supports the local food economy in a holistic perspective. Weiland stresses the importance of strong relationships creating a strong food system. She and the board of directors work hard to cultivate an open dialogue among consumers, farmers and restaurants while supporting the dynamic foodscape in this community.

MEGAN FRENCH,
LOCAL FOOD ADVOCATE

I first met Megan French at Fields Farm and saw her often at the Bend Farmers' Market. She asked about this book and gave suggestions on farms and chefs to research and possibly interview. I was impressed by her passion, knowledge and dedication. She is the perfect person to highlight for her work in the local food community.

Talk about the farm culture here.
The farm culture in the High Desert is definitely unique in a lot of ways. The seasons for farming vegetables are very defined by frost dates and the cold. The seasons can be extended, yes, but not indefinitely. I think it creates a much-needed rest period for many vegetable farmers in the area. I have noticed a sort of go-with-the-flow mentality in many of the young organic veggie farmers in the area too. There is hustle, but there is understanding as well. It's a very nice environment to be surrounded by such life-loving, levelheaded young farmers.

The issues farmers face in the High Desert are much different than in the Willamette Valley as well. We do not often have to worry about issues of oversaturation or rot, nor do we have much in the way of fungal problems. We see difficulties in the sun's intensity and the winter's intensity; hail, random frosts, etc.

I believe the farmers and ranchers, as well as the vegetables and animals, are resilient in the High Desert. The fluctuation in temperature, the dusty ground, the miles of barren land have challenged us all…and made us stronger.

The average age of a farmer in Deschutes County is fifty-nine years old. There seem to be many young farmers and several women involved in the farming community here. What needs to happen to attract more young farmers?

I believe access to land is one of the biggest difficulties a young farmer faces. Without years of credit and savings, and often looming college debt, purchasing and leasing land can be very difficult. Also, start-up information about irrigation rights, taxes, bookkeeping, access to grant money, etc. can all be very confusing and difficult to research if you are new to the concepts. I believe that mentoring young farmers, creating better access to land and having a third party to negotiate deals and succession planning for young and old farmers would help attract more young farmers.

Talk about your new farm adventure with David. How many acres? What will you grow? Anything you're looking forward in particular to growing? What's your farming philosophy?

Growing with David is a dream come true; we are so aligned in our values, farming practices and life visions. We have seventeen irrigated acres in Alfalfa. Currently, we have tilled and cover-cropped five acres. Our short-term plan is to plant large crops of asparagus and strawberries, as well as work with Agricultural Connections and other restaurants on wholesale crops. We will use animals in rotational grazing to increase fertility on the land, as well as provide our family with high-quality pasture-raised meats. We hope to plant many perennials as well, including medicinal herbs, orchard trees and berries. We hope to be a part of a farmers' market in 2018 and may move on to include a CSA in the future. Our long-term plans really just involve growing access to local food in Central Oregon, creating a composting system on the farm that meets the needs of all of our soil fertility and tending the land in the most nourishing and rewarding ways we can.

You mentioned riding a horse for twelve hours with Vaquero Valley Ranch & Cattle Company. Tell me about that experience. What did you learn from it? Did anything surprise you about the ride?

My day with the Miller family was one of the most exciting and enjoyable experiences I have ever been fortunate enough to be a part of. Ron Miller invited me out to gather the cows and move them to new land. The day began with a short investigation of the nearby boat launch at Prineville Reservoir, where he had heard a pair of his cows had been camping out. Sure enough, they were to be found and were scurried back up the High Desert draw

near the range of the other cattle. The morning went on, Logan [his son] and I on foot, searching the areas the horses weren't comfortable going, and Ron and his companions on horseback searching acres of Bureau of Land Management [BLM] for the rest of the herd. After a few hours, about 30 percent of the cows were found, and it was necessary for us to continue the journey. We had a quick bite and were off, continuing to the major duration of our trek. I was given a twenty-year-old horse that had done many rides similar to ours and had been moving cattle for all its life. A trusty old guy. The ride took us down draws, on the old highway, up hills so steep we had to get off our horses and drag them up, through a summer rainstorm and finally to their new grassy pasture.

The most surprising part of the whole day was my sense of satisfaction at the end of the day—the positive energy of the Miller family, their confidence, their ease was all so impressive and inspiring. I will never forget that day and hope to do it again soon.

Why should people care about buying and eating local food?

I know I've said this time and time again, but eating locally is not just about food. To live, humans need three things: water, food and shelter. We've taken these three most basic concepts and made them entirely too complicated. We have gone from hunters and gatherers, to agriculturists, to manufacturers. We have added multiple steps, processing, fossil fuels and outside elements to a ready-to-go product. With the rapidness of daily life, we have taken the nutrients and the joy out of the simple. I believe that local food brings back that joy.

I think people should care about eating locally because it is better for:

- The environment: Eating locally means produce is not traveling farther than your definition of local. For me, that definition is never eating food out of season and not buying anything that can be grown in Central Oregon from outside the High Desert. For example, I will only eat things like tomatoes, kale, potatoes, etc. during their season (unless I have preserved them) in Central Oregon. I do purchase/U-pick items like fruit, berries, etc. from the Willamette Valley because it grows there (we can grow some here, but currently there are no large operations). I am also guilty of purchasing chocolate and coffee from outside the country; those items are only grown outside the continental United States. When purchasing those items, I try to buy in bulk and from a distributor or company I trust.

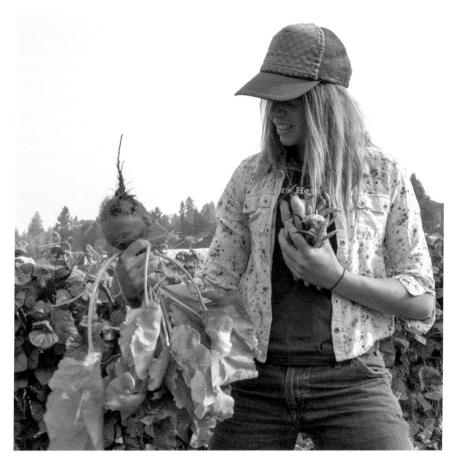

Megan French holds a beet, fava beans and dragon tongue bush beans at Fields Farm. *Photo by Emil Teague.*

- Our health: Eating locally often means bypassing packaged and processed goods. I have nearly cut out all packaged items in my diet, except for the occasional Bontà Gelato temptation. When the only choice is to eat *whole* non-processed items, it makes healthy eating and decision-making easy. Local food is also thought to have more nutrients and vitamins because of the amount of time from field to table than those that have traveled.

 "Vitamin C losses in vegetables stored at 4°C for seven days range from 15% for green peas to 77% for green beans. Refrigeration slows deterioration of vitamin C, as demonstrated

in the case of broccoli, where losses after seven days of storage were 0 at 0°C but 56% at 20°C. It should be noted, however, that 20°C storage of broccoli for seven days is atypical and would result in a wilted, yellowed product that would in all likelihood not be consumed," according to the University of California Fruit & Vegetable Preservation Resources website.

- Our community: Eating locally not only supports the local economy by keeping your dollars so close to home, supporting your neighbors and businesses, but also supports the community in a more holistic sense. You are supporting something so wholesome that an individual and his/her crew and family has given their everything to. It's a pretty amazing feeling and a gift.

What sparked your passion for seeking out local food and then ultimately working on a farm?

For many of my childhood years, we lived in a very small town of only about five hundred people. We were not too far from "civilization" (only about forty-five minutes to Salem), but the distance and our small income made my mother into an avid canner. We often sat around popping the tops off of beans, slicing strawberries or picking blackberries for my mother to can. My father was a fisherman and archery hunter, so we often relied on him for meat. Eventually, we moved to a larger town and started purchasing from the grocery store, but we always still gardened and cooked together.

As a young adult, in my first days of college, I stumbled upon the University of Oregon's Urban Farm. As I meandered around, I was greeted by the Urban Farm professor/farmer, who handed me my first beet. I asked him what to do with it, and he gave me a myriad of answers, but as I walked away he said, "Oh yeah, don't forget to eat the greens. Cook them in bacon fat." I knew I was in the right place. Through the Urban Farm and my degree in journalism, all of my research, free time, volunteering, etc., it all focused around sustainable food practices. I had my own community garden, worked at a bakery for four years, canned hundreds of pounds of food for the winter, volunteered at the Willamette Farm and Food Coalition, taught myself to hunt mushrooms and forage, wrote for a food and farm magazine and more. I was hooked.

What motivated you to become such a vocal and involved advocate for the local food movement here?
Once you meet the people growing, making, producing and cooking the food, you can't help it. The passion is contagious and the efforts valiant. I want to help these people who put their heart and souls into providing an absolute necessity to the community. Farming is not just about growing food anymore; you must be the laborer, salesman, marketer, information technology person and delivery driver. I can help fill in some of those gaps for farmers.

Where would you like to see the farming community in five years?
I would like to see a larger and more thriving farming community. It is not the farmers that drive demand, it is the demand that drives the farmers. We need community support, we need voices, we need eaters to make that happen.

What's your favorite vegetable to eat?
My favorite vegetable ever is the elegant leek. Leeks are so versatile; you can make complex and rich foods like vichyssoise, or you can broil them with butter and spread on toast. When leek season is around, you can find it in every scramble, sauté, frittata and soup I make.

What's your favorite vegetable to grow and why?
I love growing cabbage. They are hearty and hefty, require little weeding, are fun to harvest and are the base of some of my favorite foods in the world, kraut and kimchi.

Give us a recipe for a fresh vegetable anyone can cook.
My trick for eating locally every meal is to have two or three meals you love and understand how to adjust them. One of my go-to meals is tacos. Tortilla + local meat + seasonal veggie. In the spring, I might have carnitas with radishes and arugula. In the summer, chicken with sautéed peppers and charred tomatoes. In the fall, cabbage and shredded carrots. And in the winter, preserved pickled jalapeños, kimchi or kraut and red onion.

Another favorite is frittata. Sauté your veggies in a cast-iron skillet, add your egg + milk + herb mixture and toss in the oven at 350 degrees. Ready in about fifteen minutes. The best thing about frittata is you can make it as down-homey or as elegant as you like; you can make a sausage, sweet

An early morning of harvesting at Fields Farm. *Photo by Emil Teague.*

potato and roasted red pepper frittata topped with country gravy, or you can make a delicate leek frittata sprinkled with chèvre and a drizzle of balsamic vinegar on a bed of arugula.

Food can be simple. Let's not complicate any more of life than we already have.

LESSONS LEARNED
AND MOVING FORWARD

The farm-to-table movement will continue to grow as more restaurants, food carts, institutions and grocery stores source locally grown foods due to demand. Consumers are changing as well and asking questions about their food. By shopping at farmers' markets or Central Oregon Locavore or being a CSA member, they're making local habit. It's not a fad. During the research for this book, I noticed several common threads from my interviews and time spent on farms or in restaurants. Here are some ideas to contemplate as the farm-to-table movement grows:

- Easier entry into farming is needed. As I stated before, the average age of a farmer in Deschutes County is fifty-nine years old. As farmers retire, what happens to their land and equipment? Affordable land is the largest barrier into farming. Welcome the next generation of farmers by offering resources for buying or leasing land, planting crops and entering the marketplace.
- Continued open dialogue between chefs and farmers is necessary. Thinking back to my conversation with Chef Mason at French Market, he said the relationship with farmers and chefs in California is strong and reciprocal due to the continued communication over the years. Chefs want certain ingredients for menu items, and farms grow it for them. Farmers do not

solely rely on CSA shares or farmers' markets to move their product. I know it's not as simple as it sounds, but keep the conversation moving forward.

My affection and admiration for farmers and chefs has increased tremendously, and I find myself dreaming about harvesting beets in my own garden or having a backyard coop for chickens. I also started connecting more over food with friends in small, mindful ways. When I had two cases of overripe bananas leftover from a catering job, I baked fourteen loaves of banana bread and delivered them to friends. We took a moment during the busy summer and visited. Our plum trees were loaded, so I collected bags of sweet plums and gave them to everyone. I definitely agree with Megan French, who said it's about breaking bread together.

When visiting Dome Grown Produce, I saw eggplants thriving in the humid greenhouse. I made a mental note to buy them in a few weeks when ripe since I love making eggplant sandwiches. At harvest time, I drove to the Redmond Farmers' Market and bought several eggplants, along with four cucumbers for pickles. While there, Amanda offered me a sample of ground cherries, and I was hooked. After buying a pint, I shared them with friends. They had not heard of or tasted ground cherries either. After I gave some to my friend Jill, she immediately looked on Pinterest for recipes using them and asked me where to buy her own pint. Joining others in spreading the gospel of ground cherries…

I bought cucumbers, onion and basil from the farmers' market for a panzanella salad, but cherry tomatoes were sold out by the time I arrived there. Central Oregon Locavore is near my home, so I stopped in and bought a pint. They had two options from local farms, and the price was nearly the same as at the grocery store. It took very little effort to make that happen, and I enjoyed delicious locally grown produce in my salad.

I'm thrilled to know about Agricultural Connections, where I order what I want from their website and pick it up on Wednesday at their warehouse or Central Oregon Locavore, both less than two miles from my home. I would love a CSA share from a farm, but I'm often out of town during the summer. Having options to accommodate my lifestyle makes eating local simple.

Next up is a vegetable garden in my sunny front yard. My husband and I bought a home in 2016, and I want to transform the brown, dry lawn into raised beds with carrots, cucumbers, beans and more. I look forward to harvesting my own produce and sharing it with neighbors and friends.

They often receive baked goods from me on their doorstep, so it'll be a nice change to leave a bag of carrots! No kale though; I'll likely be the only gardener in Bend without it.

I hope you'll incorporate at few changes in your routine. It doesn't have to be all or nothing. Even small changes make an impact. You'll be kinder to the environment and support your community. Invite a friend to go with you to the farmers' market. Don't forget to indulge in a scoop of gelato there! Split a CSA with a friend. Buy a new-to-you vegetable and ask the farmer for tips on preparation. Try bok choy dipped in peanut butter. (Thanks, Benji!) Express gratitude to the chef and server at a restaurant for buying locally and supporting farmers. Take your family on a farm tour. Volunteer for a farmwork project. Revel in the spiciness of a French Breakfast radish or a freshly harvested sweet carrot. Thanks for supporting your community!

RESOURCES

Agricultural Connections, www.agriculturalconnections.com
Annie's Kitchen, www.anniejohnston.com
Ariana Restaurant, www.arianarestaurantbend.com
Barley Beef, www.barleybeef.com
Barrio, www.barriobend.com
Bend Art Center, www.bendartcenter.org
Bend Farmers' Market, www.bendfarmersmarket.com
Bend Pizza Kitchen, www.bendpizzakitchen.com
Bend's Makers District, www.bendsmakersdistrict.com
Big Ed's Artisan Bread, www.bigedsbread.com
Bite of Bend, www.biteofbend.com
Bontà Gelato, www.bontagelato.com
Boone Dog Wood Fired Pizza, www.boonedogpizza.com
Bos Taurus, www.bostaurussteak.com
Boundless Farmstead, www.boundlessfarmstead.com
Broken Top Bottle Shop & Ale Café, www.btbsbend.com
Brother Jon's Public House, www.brotherjonspublichouse.com
Camas Country Mill, www.camascountrymill.com
Central Milling, www.centralmilling.com
Central Oregon Health Council, www.cohealthcouncil.org
Central Oregon Intergovernmental Council, www.coic2.org
Central Oregon Locavore, www.centraloregonlocavore.org
Central Oregon Seed Exchange, www.seedexchange.weebly.com

Chez Panisse, www.chezpanisse.com/intro.php

CHOW, www.chowbend.com

Craft Kitchen & Brewery, www.craftkitchenandbrewery.com

Creative Feast, www.bendartcenter.org/creative-feasts

DD Ranch, www.ddranch.net

Deschutes Brewery & Public House, www.deschutesbrewery.com/pubs/bend

Deschutes Historical Society & Museum, www.deschuteshistory.org

Dome Grown Produce, www.domegrown.org

Dump City Dumplings, www.facebook.com/DumpCityDumplings

Earthbound Farm, www.earthboundfarm.com

Fields Farm, http://fields.farm

Fire Island Rustic Bakeshop, www.fireislandbread.com

Fred Meyer, www.fredmeyer.com

Golden Eagle Organics, Inc., www.goldeneagleorganics.com

Good Karma Bakery, www.goodkarmabakerybend541.com

Great American Egg, www.greatamericanegg.com/blog

Hank's Seafood Restaurant, www.hanksseafoodrestaurant.com

The Herbfarm, www.theherbfarm.com

High Desert Food & Farm Alliance, www.hdffa.org

Holm Made Toffee, www.holmmadetoffee.com

Hope Springs Dairy, www.hopespringsdairy.com

Imperial, www.imperialpdx.com

Indian Line Farm, www.indianlinefarm.com

Jackson's Corner, www.jacksonscornerbend.com

Last Saturday at the Workhouse, www.theworkhousebend.com/last-saturday.html

Local Slice, www.localslicebend.com

Lone Pine Coffee Roasters, www.lonepinecoffeeroasters.com

Mahonia Gardens, www.mahoniagardens.com

Market of Choice, www.marketofchoice.com

Melvin's, www.melvinsbynam.com

Michael Pollan, www.michaelpollan.com

Mohawk Valley Meats, www.mohawkvalleymeats.com

Natural Resources Conservation Service, www.nrcs.usda.gov/wps/portal/nrcs/site/national/home

Newport Avenue Market, www.newportavemarket.com

NorthWest Crossing, www.northwestcrossing.com

NorthWest Crossing Farmers' Market, www.nwxfarmersmarket.com

Novicky's Farm, www.novickysfarm.com

123 Ramen, www.123ramenbend.com

The Open Door Restaurant, www.opendoorwinebar.com

Oregon Department of Agriculture, www.oregon.gov/oda/Pages/default.aspx

Oregon State University Extension Service Master Gardener, www.extension.oregonstate.edu/mg

Organic Materials Review Institute, www.omri.org

Pepperberries, www.pepperberriesinc.com

Pine State Biscuits, www.pinestatebiscuits.com

Planker Sandwiches, www.plankersandwiches.com

Pono Farm & Fine Meats, www.ponofarm.com

Portland Meat Collective, www.pdxmeat.com

Primal Cuts Market, www.primalcutsmeatmarket.com

Radicle Roots Farm, www.radiclerootsfarm.com

Rainshadow Organics, www.rainshadoworganics.com

Redmond Farmers' Market, www.facebook.com/redmondoregonfarmersmarket

Rogue Farm Corps, www.roguefarmcorps.org

Sakari Botanicals, www.sakaribotanicals.weebly.com

Save the Food, www.savethefood.com

Schoolhouse Produce, www.schoolhouseproduce.com

Screen Door, www.screendoorrestaurant.com

Seed to Table Farm, www.seedtotableoregon.org

Sip Wine Bar, www.sipwinebend.com

Sisters Farmers' Market, www.sistersfarmersmarket.com

String Theory Music, www.stringtheorymusicbend.com

Sunny Yoga Kitchen, www.sunnyyogakitchen.com

Sunriver Brewing Company, www.sunriverbrewingcompany.com

The Temple-Wilton Community Farm, www.twcfarm.com

Thump Coffee, www.thumpcoffee.com/bend

Tommy's Country Ham House, www.tommyscountryhamhouse.com

Tumalo Farmstand, www.facebook.com/tumalofarmstand

Tumalo Fish and Vegetable Farm, bob@tumalofamilyfarm.com

Umi Organic, www.umiorganic.com

U.S. Department of Agriculture, www.usda.gov

U.S. Department of Agriculture New Farmers, www.newfarmers.usda.gov

Vaquero Valley Ranch & Cattle Company, www.bendbeef.com

Windflower Farm, www.windflowerfarmbend.com

Zuni Café, www.zunicafe.com

BIBLIOGRAPHY

In addition to the sources here, the author relied on in-person interviews, telephone and e-mail communication. A wonderful list of additional restaurants, farms and producers is available at www.hdffa.org.

Aguilar, George. *When the River Ran Wild*. Portland: Oregon Historical Society Press, 2005.

Alt, David D., and Donald W. Hyndman. *Roadside Geology of Oregon*. Missoula: Mountain Press Publishing Co., 1978.

The Aquaponic Source. "What Is Aquaponics?" www.theaquaponicsource. com/what-is-aquaponics.

Arcuri, Lauren. "Definition of Candling: How to Candle an Egg." The Spruce, February 27, 2018. www.thespruce.com/definition-of-candling-3016955.

Australis, the Better Fish. "Barramundi 101." www.thebetterfish.com/why-barramundi.

Barrett, Diane M. "Maximizing the Nutritional Value of Fruits & Vegetables." University of California Fruit & Vegetable Preservation Resources. www. fruitandvegetable.ucdavis.edu/files/197179.pdf.

Bilow, Rochelle. "Yes, You Can Eat That: How to Cook with Kohlrabi from the Market." *Bon Appétit*, October 8, 2015. www.bonappetit.com/test-kitchen/ingredients/article/from-the-market-kohlrabi.

Biodynamic Association. "What Is Biodynamics?" www.biodynamics.com/what-is-biodynamics.

Boer Goats Home. "Boer Goats for Beginners." www.boergoatshome.com/boer_goats_for_beginners.php.

Bonnie Plants. "5 Variations on a String Trellis for Tomatoes." bonnieplants.com/2014/05/string-trellis-for-tomatoes-variations.

———. "Growing Artichokes." bonnieplants.com/growing/growing-artichoke.

Boudway, Ira. "We Are What We Eat: Interview with Michael Pollan." Michael Pollan, April 8, 2006. michaelpollan.com/interviews/we-are-what-we-eat.

Burns, Joe. "C. Oregon Ranchers Turn Beer Waste into Beef." *KTVZ*, July 12, 2013. www.ktvz.com/news/deschutes-county/c-oregon-ranchers-turn-beer-waste-into-beef/68483600.

Byczynski, Lynn. *Market Farming Success*. White River Junction, VT: Chelsea Green Publishing, 2006.

Carey, Charles H. *General History of Oregon*. Portland, OR: Binsford & Mort, 1971.

Cascade Business News. "New Bistro Opens in Bend—French Market." *Cascade Business News*, July 11, 2017.

Castillo, Julie. *Eat Local for Less*. Washington, D.C.: Ruke Press, 2015.

Cedar Circle Farm. "Garlic Scapes." cedarcirclefarm.org/tips/entry/garlic-scapes.

Chhabra, Esha. "Biodynamic Farming Is on the Rise: But How Effective Is this Alternative Agricultural Practice?" *The Guardian*, March 5, 2017. www.theguardian.com/sustainable-business/2017/mar/05/biodynamic-farming-agriculture-organic-food-production-environment.

Cotler, Amy. *The Locavore Way*. North Adams, MA: Storey Publishing, 2009.

Cressman, L.S. *The Sandal and the Cave*. Corvallis, OR: Bearer Books, 1960.

Culinary Schools. "What Is the Farm-to-Table Movement?" www.culinaryschools.com/farm-to-table-movement.

Denny, Sharon. "Taste Fennel's Distinctive Flavor." Food & Nutrition, August 28, 2015. foodandnutrition.org/september-october-2015/taste-fennels-distinctive-flavor.

Deschutes County Historical Society. *Bend 100 Years of History*. Battle Ground, WA: Pediment Publishing, 2004.

———. Images of America. *Bend*. Charleston, SC: Arcadia Publishing, 2009.

Devold, David. "The Easiest Way to Train Pigs to an Electric Fence." Off the Grid News. www.offthegridnews.com/how-to-2/the-easiest-way-to-train-pigs-to-an-electric-fence.

Diab, Emma. "What It Really Means When a Restaurant Is 'Farm-to-Table.'" Thrillist, March 24, 2016. www.thrillist.com/eat/nation/what-it-really-means-when-a-restaurant-is-farm-to-table.

Dicken, Samuel N., and Emily F. Dicken. *The Making of Oregon*. Portland: Oregon Historical Society, 1979.

Ditzler, Joseph. "Community Support Keeps Tomato Farm Growing." *Bulletin*, July 16, 2017.

Dr. Axe. "Fennel Benefits, Nutrition and Fantastic Recipes." draxe.com/fennel-benefits-nutrition-fantastic-recipes.

Earthbound Farms. "Our Heritage." www.earthboundfarm.com/about/our-heritage.

Einkorn. "The History of Einkorn, Nature's First and Oldest Wheat." www.einkorn.com/einkorn-history.

Encyclopedia Britannica. "Marmot." www.britannica.com/animal/marmot.

Engeman, Richard. *The Oregon Companion*. Portland, OR: Timber Press, 2009.

Farmers Market Coalition. "What Is a Farmers Market?" farmersmarketcoalition.org/education/qanda.

The Fish Site, July 31, 2006. thefishsite.com/articles/the-benefits-of-fish-meal-in-aquaculture-diets.

Fletcher, Janet. *Eating Local: The Cookbook Inspired by America's Farmers*. Kansas City, MO: Andrews McMeel Publishing, 2010.

The Food for Everyone Foundation. "What Is the Mittleider Method?" growfood.com/#whatis.

Forge, Arabella. *Frugavore*. New York: Skyhorse Publishing, 2011.

Fossel, Peter V. *Organic Farming*. McGregor, MN: Voyageur Press, 2007.

Furry, Darin. *Beyond Sagebrush II*. Bend, OR: DF Publications, LLC, 2015.

The Gardening Cook. "Barramundi Recipe with Garlic Lemon Butter Sauce." thegardeningcook.com/barramundi-with-lemon-butter-sauce.

Gardening Know How. www.gardeningknowhow.com.

Group, Dr. Edward. "5 Health Benefits of Brahmi (Bacopa monnieri)." Global Healing Center, June 19, 2014. www.globalhealingcenter.com/natural-health/health-benefits-of-brahmi-bacopa-monnieri.

Gourmet Garlic Gardens. "Curing the Garlic." www.gourmetgarlicgardens.com/curing-and-storing-the-garlic.html.

Happy Heart Farm. "Biodynamic Farming." happyheartfarmcsa.com/biodynamic-farming.

Harrison, Glenn. "Santiam Wagon Road." The Oregon Encyclopedia. oregonencyclopedia.org/articles/santiam_wagon_road/#.WjG_Gt9Ktdg.

Health Line. "Lamb 101: Nutrition Facts and Health Effects." www.healthline.com/nutrition/foods/lamb#section5.

Hurst, Janet. *The Farm to Market Handbook*. McGregor, MN: Voyageur Press, 2014.

Jennings, Brian. "Changing of the Guard." *The Source Weekly*, November 25, 2015.

Johnson, Alandra. "Couple Starts a Small Farm in Sisters." *Bulletin*, June 22, 2013.

Jones, Allison. "Wildwood Closing after 20 Years in Northwest Portland." *Portland Monthly*, February 18, 2014. www.pdxmonthly.com/articles/2014/2/18/wildwood-closing-after-20-years-in-northwest-portland-february-2014.

Katahdin Hair Sheep International. www.katahdins.org.

Kikkoman. "Making Soy Sauce." www.kikkoman.com/en/shokuiku/soysaucemuseum/making/index_en.html.

King, Hobart M. "Obsidian." Geoscience News and Information. geology.com/rocks/obsidian.shtml.

Kirchhoff, John. "Secrets of Raising Katahdin Sheep." Countryside Daily, January 24, 2018. countrysidenetwork.com/daily/livestock/sheep/secrets-of-raising-katahdin-sheep.

The Kitchn. "How to Pickle Ginger." www.thekitchn.com/how-to-pickle-ginger-234166.

Korfhage, Matthew. "Wildwood Closed Two Years Ago after Steep Rent Hike. Now, It's Portland's Best Undead Restaurant." *Willamette Week*, October 3, 2016. www.wweek.com/restaurants/2016/07/12/wildwood-is-portlands-best-undead-restaurant.

Laugaard, O. *Final Report of the Construction of Tumalo Irrigation Project*. Oregon, 1914.

Leland, Caroline. "Farmer's Blues." *Gravy*, podcast audio, May 18, 2007.

LiveAquaria. "Basic Water Chemistry Part 3: Ammonia, Nitrites and Nitrates." www.liveaquaria.com/pic/article.cfm?aid=62.

Local Harvest. "Community Supported Agriculture." https://www.localharvest.org/csa.

———. "Questions You Might Ask Your CSA." www.localharvest.org/csa/questions-for-csa.jsp.

Local Slice. "Local Bounty, Global Taste." www.bendinspoon.com/our-food-philosophy.

Lopez-Alt, J. Kenji. "Sous Vide Leg of Lamb with Black Olives Recipe." Serious Eats. www.seriouseats.com/recipes/2016/10/sous-vide-leg-of-lamb-with-black-olives-recipe.html.

Manning, Ivy. *The Farm to Table Cookbook: The Art of Eating Locally*. Seattle, WA: Sasquatch Books, 2008.

Martin, Jacqueline Briggs. *Alice Waters and the Trip to Delicious*. Bellevue, WA: Readers to Eaters, 2014.

Martin, Katie. "Newport Market: First, Fast and Different." *Gourmet Retailer*, April/May 2017, 12.

Martin, Kristin. "Top 5 Facts You Didn't Know About Rhubarb." The Town Dish. www.thetowndish.com/news/2014/top-5-facts-didnt-know-rhubarb.

Meredith, Leda. *The Locavore's Handbook*. Guilford, CT: Lyons Press, 2010.

Morris, Gregg. "Passion Centered at Sunny Yoga Kitchen in Bend, Oregon." *Cascade Business News*, February 17, 2015.

Moses Organic Fact Sheet. "Transitioning to Organic Crop Production." mosesorganic.org/wp-content/uploads/Publications/Fact_Sheets/24transCrop.pdf.

National Agricultural Statistics Service. "USDA Releases Results of First Local Food Marketing Practices Survey Oregon and Washington Highlights." News release, December 21, 2016. www.nass.usda.gov/Statistics_by_State/Washington/Publications/Current_News_Release/2016/LF1216.pdf.

Nomiku. "What Is Sous Vide?" www.nomiku.com/pages/what-is-sous-vide.

Olsen, Tom. "Growing Tomatoes Takes Dedication." *Bulletin*, April 17, 2002.

Oregon Agriculture Facts & Figures. Pamphlet, August 2016.

Oregon Department of Geology and Mineral Industries. www.oregongeology.org/pubs/index.htm.

Oregon.gov Water Resources Department. "Water Rights." www.oregon.gov/owrd/pages/wr/index.aspx.

The Oregon History Project. "High Desert History: Southeastern Oregon: Settling Up the Country: On the Far Fringes of Two Empires." oregonhistoryproject.org/narratives/high-desert-history-southeastern-oregon/resettlement/on-the-far-fringes-of-two-empires/#.WjG91t9Ktdg.

Oregon State Extension Service. "Purple Tomato Debuts as 'Indigo Rose.'" January 27, 2012. extension.oregonstate.edu/gardening/purple-tomato-debuts-indigo-rose.

Organic Facts. "10 Surprising Benefits of Kohlrabi." www.organicfacts.net/health-benefits/vegetable/health-benefits-of-kohlrabi.html.

Parsons, Russ. *How to Pick a Peach*. Boston: Houghton Mifflin Company, 2007.

Pennington. "What Is Fish Fertilizer?" www.pennington.com/resources/fertilizer/edible-gardening/what-is-fish-fertilizer.

Pokarney, Bruce. *Oregon Harvest*. Woodburn, OR: Beautiful America Publishing, 2002.

Pollinator Partnership. "Pollination." pollinator.org/pollination.

Portland Nursery. "Mahonia: Oregon Grape." portlandnursery.com/plants/natives/mahonia.shtml.

The Prepper Project. "What You Might Not Know About Fresh Chicken Eggs." theprepperproject.com/might-know-fresh-chicken-eggs.

Pritchard, Forrest. *Growing Tomorrow*. New York: Experiment, 2015.

Raising Sheep. "Suffolk Sheep Breed Information, History and Facts." www.raisingsheep.net/suffolk.html.

Robbins, William G. *Oregon, This Storied Land*. Portland: Oregon Historical Society Press, 2005.

Ruby, Jeff. "Rolled vs. Hand-Stretched Pizza Dough." *Chicago Mag*, July 7, 2010. www.chicagomag.com/Chicago-Magazine/July-2010/Rolled-vs-Hand-Stretched-Pizza-Dough.

Seed Sheet. "Trellis Tips: How to Set Your Tomatoes Up for Success in the Garden." www.seedsheets.com/new-blog/howtotrellistomatoes.

Sheep 101. "Selecting a Breed of Sheep." www.sheep101.info/201/breedselection.htm.

Simonson, Lisa. "Is Goat Meat Healthy?" Live Strong, October 3, 2017. www.livestrong.com/article/367559-is-goat-meat-healthy.

Simple Good and Tasty. "Goat: The World's Favorite Meat." simplegoodandtasty.com/2011/04/06/goat-the-worlds-favorite-meat.

Sipe, Lisa. "Downward Dog Not Required." *The Source Weekly*, May 3, 2017.
———. "Pop-Up Creative Feast." *The Source Weekly*, August 31, 2017.

Sisters Oregon Guide. "Fast Facts about Sisters Oregon." www.sistersoregonguide.com/sisters-facts.htm.

Slow Food USA. "Eat Nose-to-Tail." www.slowfoodusa.org/eat-nose-to-tail.

Specialty Produce. "French Breakfast Radish." www.specialtyproduce.com/produce/French_Breakfast_Radish_417.php.
———. "Radicchio." www.specialtyproduce.com/produce/Radicchio_502.php.
———. "Treviso." www.specialtyproduce.com/produce/Treviso_5021.php.

Spurr, Kyle. "NorthWest Crossing Farmers Market in Full Swing." *Bulletin*, July 8, 2017.

State of Oregon. "Overview of the Nine Tribes." www.oregon.gov/DHS/ABOUTDHS/TRIBES/Pages/Tribes.aspx.

St. John, Alan D. *Oregon's Dry Side*. Portland, OR: Timber Press, 2007.

Sustainability at Work. "Deschutes Brewery Portland Public House." www.portlandoregon.gov/sustainabilityatwork/article/540172.

Taylor, George H., and Raymond R. Hatton. *The Oregon Weather Book.* Corvallis: Oregon State University Press, 1999.

Towers, Lucy. "How to Farm Barramundi." The Fish Site, April 12, 2010. thefishsite.com/articles/cultured-aquaculture-species-barramundi.

Travel Oregon. "Native American Culture." traveloregon.com/things-to-do/culture-history/native-american-culture.

———. "Oregon Weather." traveloregon.com/oregon-weather.

Trimarchi, Maria. "How Biodynamic Agriculture Works." How Stuff Works. science.howstuffworks.com/environmental/green-science/biodynamic-agriculture1.htm.

2012 Census of Agriculture: Deschutes, Crook and Jefferson County.

University of California Cooperative Extension. "Selling to Restaurants." sfp.ucdavis.edu/pubs/SFNews/archives/92072.

University of Minnesota Extension. "Controlling Quackgrass in Gardens." www.extension.umn.edu/garden/yard-garden/weeds/controlling-quackgrass-in-gardens.

Upson, Steve. "Hoop House Horticulture Creates Many Benefits." Noble Research Institute, February 1, 2014. www.noble.org/news/publications/ag-news-and-views/2014/february/hoop-house-horticulture-creates-many-benefits.

U.S. Climate Data. "Climate: Eugene, Oregon." www.usclimatedata.com/climate/eugene/oregon/united-states/usor0118.

———. "Climate: Newport, Oregon." www.usclimatedata.com/climate/newport/oregon/united-states/usor0245.

U.S. Department of Agriculture, Agricultural Marketing Service. "Benefits of Organic Certification." www.ams.usda.gov/services/organic-certification/benefits.

U.S. Department of Agriculture, Census of Agriculture. www.agcensus.usda.gov.

———. "Small Farms." www.agcensus.usda.gov/Publications/2007/Online_Highlights/Fact_Sheets/Farm_Numbers/small_farm.pdf.

U.S. Department of Agriculture, Economic Research Service. "What Is Food Security?" www.ers.usda.gov/topics/food-nutrition-assistance/food-security-in-the-us/measurement.

U.S. Department of Agriculture, Forest Service. "Big Obsidian Flow Trailhead and Interpretive Site." www.fs.usda.gov/recarea/deschutes/recarea/?recid=38304.

———. "Newberry National Volcanic Monument." www.fs.usda.gov/recarea/deschutes/recarea/?recid=66159.

U.S. Department of Agriculture, National Agricultural Statistics Service. "USDA's National Agriculture Statistics Service Oregon Field Office." www.nass.usda.gov/Statistics_by_State/Oregon.

Vargo, Adrianna. "4 Ways to Use a Cold Frame." *Fine Gardening*. www.finegardening.com/4-ways-use-cold-frame.

Visit Bend. www.visitbend.com.

Vital Farms. "Pasture Raised Eggs." vitalfarms.com/pasture-raised-eggs.

Ware, Megan. "The Health Benefits of Bok Choy." Medical News Today, February 7, 2018. www.medicalnewstoday.com/articles/280948.php.

Waters, Alice. *The Art of Simple Food.* New York: Clarkson Potter, 2007.

Wikipedia. "Alvord Desert." en.wikipedia.org/wiki/Alvord_Desert.

———. "Carey Act." en.wikipedia.org/wiki/Carey_Act.

Williams, Gerald W. "Santiam Pass." The Oregon Encyclopedia. oregonencyclopedia.org/articles/santiam_pass/#.WVbHUYgrJdg.

Winch, Martin. *Biography of a Place: Passages through a Central Oregon Meadow.* Bend, OR: Deschutes County Historical Society, 2006.

INDEX

ABOUT THE AUTHOR

Sara Rishforth plays ukulele, loves good food and adores her Kitchen-Aid mixer. After growing up in Greenville, South Carolina, she moved west to Alaska, where she worked for nonprofit organizations, made great friends and wrote for *Alaska's Best Kitchens* magazine. Moving to Central Oregon in 2010, Sara self-published two novels, *Adventures in Dating* and *After We Met*, loosely based on her time in the Last Frontier. Drawing from life experiences, she was a winner of the 2013 Central Oregon Writers Guild Literary Harvest, Memoir Category.

Sara, her husband and their fuzzy orange cat, Yam, are remodeling a home in Bend, Oregon. Yam does all the hard work. Sara prints season passes and sells tickets by the millions at Mount Bachelor ski resort in the winter, along with supplying baked goods for her co-workers and friends.

www.sararishforth.com

Visit us at
www.historypress.com